IMAGES
of America

MISSOURI
STATE FAIR

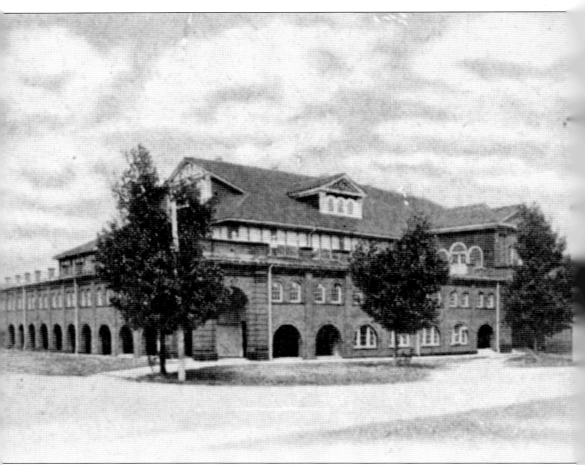

As many as 7,000 spectators could view livestock judging and exhibitions in the Live Stock Pavilion each afternoon during the fair. On Tuesday, Wednesday, and Thursday evenings, Missouri's finest saddle and harness horses demonstrated their beauty and their handlers' skill. On Sundays, crowds gathered for sacred concerts. The Coliseum, as the building is now known, features livestock shows during the fair and a variety of events throughout the rest of the year. (Courtesy of Pettis County Historical Society.)

On the Cover: The Missouri General Assembly hoped that its state fair would improve agriculture by displaying the best of Missouri products and the newest, most scientific agricultural techniques. This photograph, taken by Sedalia photographer Charles E. Coles, shows spectators examining some of the newest machinery produced by the Case Threshing Machine Company during the first decade of the 20th century. (Courtesy of Charles Wise.)

IMAGES *of America*
MISSOURI STATE FAIR

Rhonda Chalfant, PhD

Copyright © 2012 by Rhonda Chalfant, PhD
ISBN 978-0-7385-8261-0

Published by Arcadia Publishing
Charleston, South Carolina

Printed in the United States of America

Library of Congress Control Number: 2011935992

For all general information, please contact Arcadia Publishing:
Telephone 843-853-2070
Fax 843-853-0044
E-mail sales@arcadiapublishing.com
For customer service and orders:
Toll-Free 1-888-313-2665

Visit us on the Internet at www.arcadiapublishing.com

To Daddy, whose trips to the fair taught me about livestock and more about "good country boys" than he could ever possibly have realized.

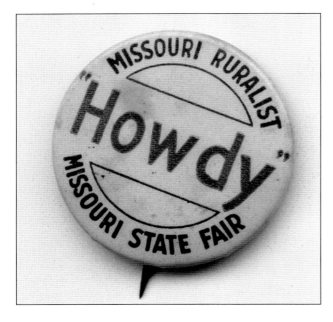

The *Missouri Ruralist*, a publication of the Rural Missouri Electric Cooperatives, distributed a pin welcoming fairgoers. (Courtesy of Charles Wise.)

Contents

Acknowledgments		6
Introduction		7
1.	Before the Fair	9
2.	At the Fairgrounds	17
3.	Going to the Fair	29
4.	Who's at the Fair?	43
5.	Seeing the Sights	55
6.	Fresh off the Farm	69
7.	For the Farm	83
8.	Around the Track	91
9.	Fun and Corn Dogs	103
10.	The State Fair City	117
Bibliography		127

Acknowledgments

Thanks are due to the many organizations and individuals who contributed to this book by providing photographs, information, and encouragement.

This book would have been impossible without the photographs and artifacts in the Pettis County Historical Society collection, including many recently acquired and heretofore unpublished photographs. Unless otherwise noted, all photographs are from the society's collection. The Missouri State Archives contributed a number of photographs, as did the Missouri State Fair. Other organizations, including the City of Marshall, the Centralia Historical Society, the Sedalia Area Chamber of Commerce, the State Fair Community College Archives and Public Relations department, and the Bothwell Lodge State Historic Site. The Sedalia Public Library contributed photographs and information from its archives as well as from its microfilm newspaper collection. The *Sedalia Democrat* provided useful information and photographs. The State Historical Society of Missouri's newspaper archive and files were also very helpful. Gary Kremer of the State Historical Society of Missouri allowed use of photographs first used by Walter Williams in 1904.

Special thanks are due to Charles Wise, who graciously provided many photographs and artifacts from his vast collection and information from his vast store of knowledge. Ken Bird, William Claycomb, A.J. Heck and Carolyn Thomas, Ellen Weathers, Van Beydler, Beth Palmer, Becky Imhauser, James Page, Byron Matson, James Keck, and Millicent Hale shared information, and I thank them.

A comment about the choice of photographs should also be provided. I attempted as much as possible to use photographs that had not been previously published. The availability of photographs influenced my choice of what to include; I did not set out to focus more on any one aspect of the fair or individual involved in the fair. Many of the photographs did not identify the people pictured. I attempted as best I could and with the help of the people mentioned above to identify them. If I have erred, I am truly sorry.

Elizabeth Bray, the editor at Arcadia Publishing, was extremely helpful in her comments on content and was very patient with my sometimes awkward attempts at making the technology of publishing work.

I also must remember my father and grandfather, who taught me to love history and encouraged me to write.

INTRODUCTION

At the turn of the 20th century, Missouri led the nation in agricultural production. The state was the fourth in the total value of its livestock, fifth in the production of cattle, third in swine production, and third in poultry production. Missouri supplied mules to armies throughout the world. Agricultural journals recognized the quality of Missouri products, praising the cattle and swine that Missouri stockmen showed at state fairs in Iowa, Illinois, and Minnesota and noting the premiums won at world's fairs, where Missouri agriculturalists won 75 percent of the prizes on livestock and crops.

Despite all of this, Missouri had no state fair at which to display the products of its agriculture and industry and no means by which the Missouri farmer could learn from the example of other producers.

Most towns and counties in Missouri held fairs where local residents showed off their animals, crops, garden produce, handiwork, and crafts. Intense competition between exhibitors spurred them to labor diligently to improve their products. The supporters of a Missouri State Fair believed this sort of competition on a state level could benefit all Missouri agriculturalists and indeed improve life for all Missourians.

In spite of regional animosity and bitter opposition, the General Assembly of Missouri finally authorized a state fair. Continued opposition hampered the funding of the fair. Even Mother Nature seemed against the idea of a state fair, sending a cold, rainy spring and an extremely dry and hot summer to plague both the builders of the fairgrounds and potential exhibitors the year of the first exhibition. Held in 1901, the first fair came, as the *Breeders' Gazette* pointed out, after "years of ardent hope, of patient, earnest effort."

Despite the vagaries of Missouri weather, the difficulties of economic depressions and recessions, and its people's participation in six wars, the Missouri State Fair continues as an institution that for more than 100 years has been a tribute to Missouri's agriculture, industry, natural resources, and its people.

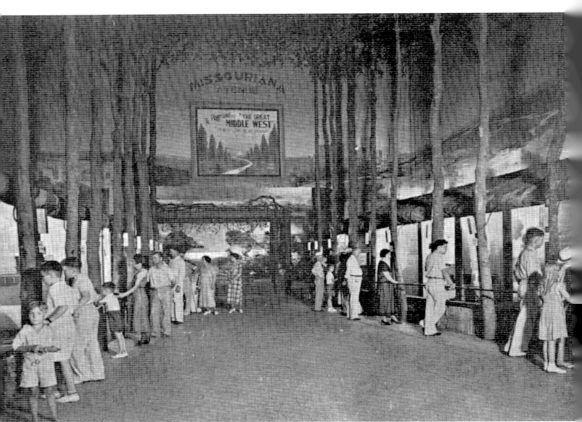

In 1933, Missouri mounted an exhibit of the state's resources at the Chicago World's Fair. In 1936, after Works Progress Administration workers remodeled the second Poultry Building, the exhibit was placed on display in the newly remodeled and renamed Missouri Building at the Missouri State Fair. (Courtesy of Missouri State Archives.)

One

BEFORE THE FAIR

Early in 1899, Missouri governor Lon Stephens encouraged the General Assembly to enact legislation that would create a state fair, an idea supported by livestock associations and farm publications. After the General Assembly voted to establish the Missouri State Fair, it appointed a State Fair Board to visit various cities to choose a location. Six cities competed to become the site of the Missouri State Fair. Each city entertained the State Fair Board lavishly, showed off its farms, industries, and amenities, and promised the state cash and land for the fairgrounds. (Courtesy of Missouri State Archives.)

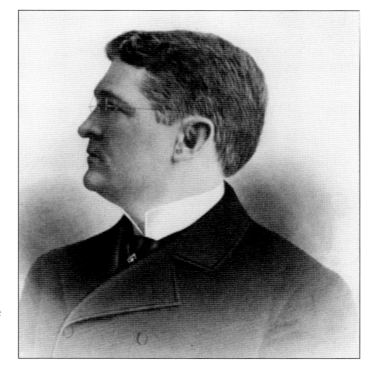

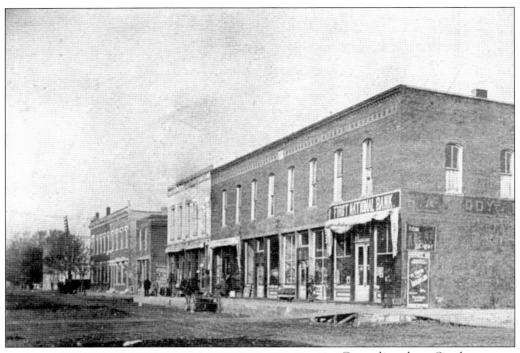

Centralia, whose Singleton Street is shown above, was the smallest of the cities with 1,700 residents. It was 24 miles from the University of Missouri College of Agriculture, a factor Centralia considered important. However, Centralia lacked paved streets and adequate water service as well as numerous hotels and restaurants to serve fairgoers. Centralia offered the state a 120-acre fairgrounds and $10,000. Centralia's Baptist Church, (shown here), the Methodist Church, and several temperance societies made Centralia "dry." The city refused to serve wine with the meal it offered the State Fair Board. After Sedalia was named the site of the fair, Centralia protested that the State Fair Board had fallen prey to the "alluring blandishments of the tempting liquid refreshments." (Both, courtesy Centralia Historical Society.)

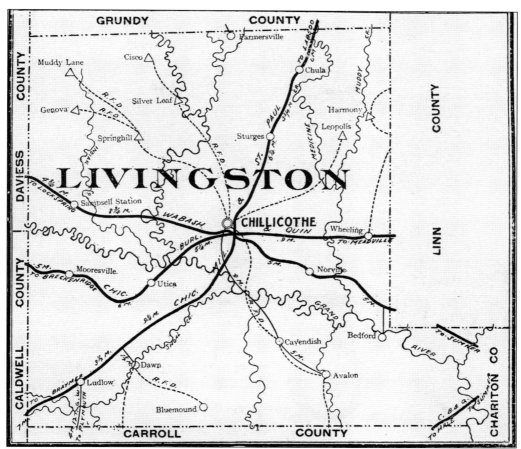

Chillicothe, Missouri, county seat of Livingstone County, was the northernmost city to compete for the fair. Chillicothe had good rail connections on the Wabash Railroad and trunk lines of both the Chicago, Burlington & Quincy Railroad and the Chicago, Milwaukee & St. Paul Railroad, but it lacked a convenient rail connection to the south.

Chillicothe was already the home of a state facility, a juvenile girls' reformatory called the State Industrial School for Girls, shown here. This institution, designed to reform incorrigible young women by teaching them the skills they would need to be good wives and mothers, housed approximately 200 girls and young women on a campus with three cottages, a school building, and a power plant. (Courtesy of the author.)

Marshall, Missouri, was the county seat of Saline County. The courthouse was centered on the public square, surrounded by business buildings and a bank on each corner. Marshall's civic amenities included public water lines, electric service, and paved streets. Marshall's four hotels and seven restaurants could accommodate the crowds visiting the state fair. Marshall offered the state 160 acres of land and $20,000 for developing the fairgrounds. (Courtesy of the author.)

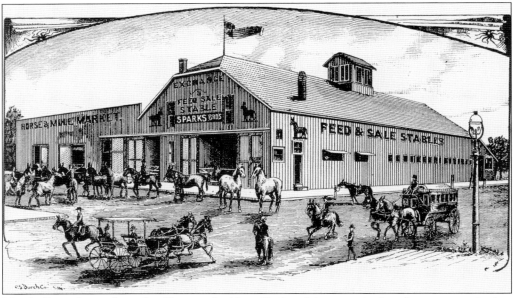

Marshall was located on the Chicago & Alton Railroad in an agricultural area recognized as having the richest and highest-priced agricultural land in Missouri. Marshall was also well known for producing quality horses and mules that were sold at Sparks Brothers' Horse and Mule Market. (Courtesy of City of Marshall, Missouri.)

Mexico, Missouri, the county seat of Audrain County, was located on the Chicago & Alton Railroad, which promised to extend its lines onto the fairgrounds. Mexico was noted for its stables, including those of Tom Bass, who trained prizewinning show horses, such as Forest King, Belle Beach, and Columbus, and Benjamin R. Middleton, shown here on one of his horses.

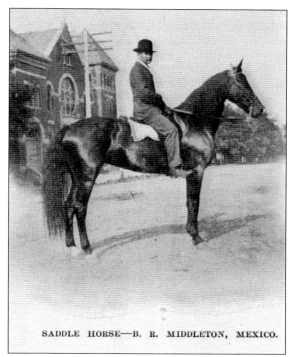

SADDLE HORSE—B. R. MIDDLETON, MEXICO.

Mexico's State Fair Committee wined and dined the members of the State Fair Board with this elaborate midday meal served at one of the city's hotels, which was preceded by a tour of farms in neighboring Callaway County and businesses in Mexico.

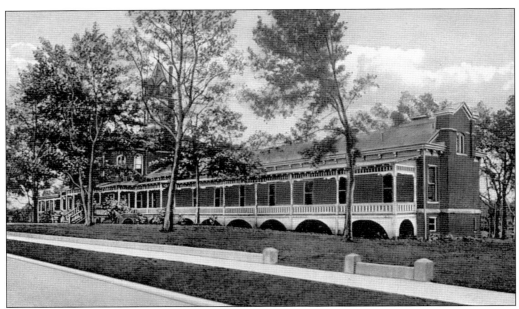

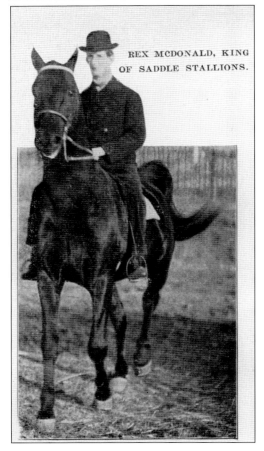

REX MCDONALD, KING OF SADDLE STALLIONS.

Moberly, Missouri, was called the Magic City because of its rapid growth. It was located on the Wabash Railroad and was home to the Wabash Railroad Shops and the Wabash Railroad Hospital, shown here. The State Fair Board toured the Wabash shops, where they were greeted by Superintendent Goodrich and given bouquets of flowers by Master Mechanic Mudd. They also toured the railroad hospital. (Author's collection.)

While at Mexico, the State Fair Board visited nearby Macon, Missouri, and toured Blees Stables, known for racehorses, such as Rex McDonald, a world champion saddle stallion who had been purchased in 1898 for $5,000 by Col. F.W. Blees of Macon.

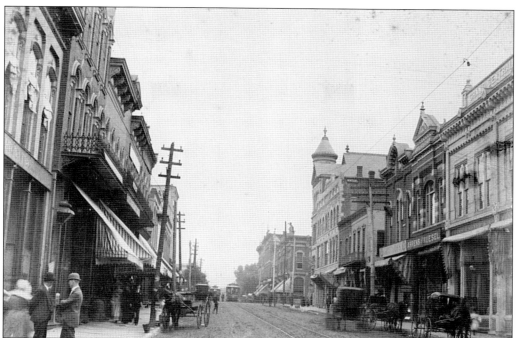

Mayor W.C. Overstreet led Sedalia during the city's efforts to secure the site of the Missouri State Fairgrounds. Sedalia, the sixth largest city in Missouri and the county seat of Pettis County, had the amenities characteristic of many larger towns—a public water supply with 35 miles of water mains, 6 miles of sewer line, electric service, 12 miles of street car line, and 9 miles of paved streets. Ohio Avenue, Sedalia's primary business street (shown above) hummed with activity. Sedalia, a center of both wholesale and retail trade, generated almost $ million worth of business per year. Sedalia's streetcar company promised to extend lines to the fairgrounds and give the state a portion of the income from the streetcar line to fund development of the fairgrounds. (Above, courtesy of Pettis County Historical Society; right, courtesy of Robert Overstreet.)

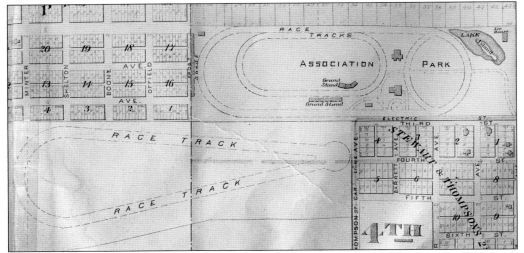

Sedalia held a local fair and fairgrounds in Association Park, later called Sicher's Park. The fairgrounds featured a hotel with a dining and assembly hall that seated 500, a machinery pavilion, a floral hall, a farm products hall, 250 sheep pens, 270 cattle stalls, telephone connections to outlying farms, a kite-shaped racetrack, and a grandstand that seated 5,000. The fairgrounds are shown on this 1896 map.

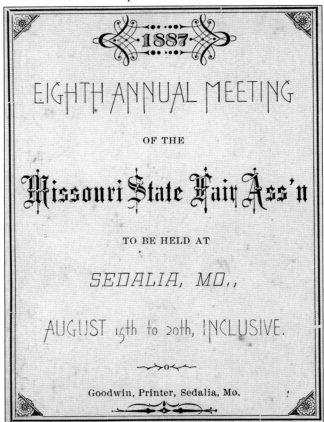

Sedalia had the audacity to call its local fair the Missouri State Fair, as this premium book from the 1887 Missouri State Fair Association shows. Sedalia's use of the term *state fair* was resented by the other communities who claimed that Sedalia had been selected as the location of the fair before the State Fair Board had even visited the other communities. (Courtesy of Charles Wise.)

Two

AT THE FAIRGROUNDS

Architect Thomas Bast designed several important buildings in Sedalia, including Washington, Whittier, and Mark Twain Elementary Schools, Bothwell Hospital, and United Church of Christ and assisted with the design of Smith-Cotton High School. In the 27 buildings Bast designed on the Missouri State Fairgrounds, he used an eclectic mix of Romanesque Revival, Mission, and Arts and Crafts style, locally known as "Bastonian." His later designs, such as those for the Administration Building and Womans Building, used the more formal Classical Revival style. Overall, Bast's work gives the fairgrounds a unique appearance. The Missouri State Fairgrounds was listed in the National Register of Historic Places in 1991.

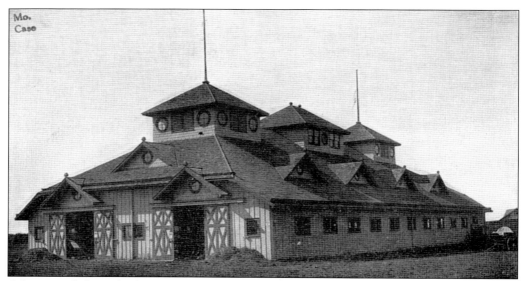

A large cattle barn, built in 1900 by H.M. Hammond, dominated the southwestern side of the fairgrounds south of the grandstand. In 1901, Joseph Heckert and S. Wilson Ricketts built a second cattle barn to house an additional 90 head of cattle. (Courtesy of Sedalia Public Library.)

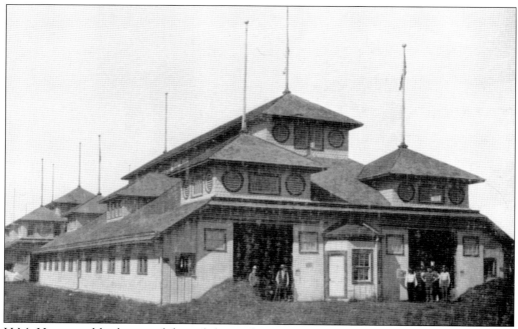

H.M. Hammond built one of the exhibition horse and mule barns in 1899. A.J. Hutchinson completed the second exhibition horse and mule barn in 1901, shortly before the first Missouri State Fair. The second barn cost $3,075. (Courtesy of Sedalia Public Library.)

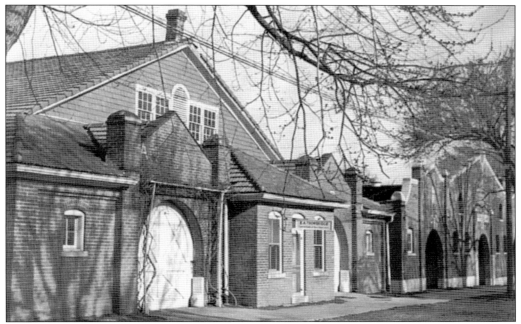

These barns, built in 1904, housed show horses. The projecting bay housed the office of E.A. Trowbridge, the dean of the Missouri College of Agriculture. The barn on the right, named for Gov. Henry Caulfield, has three arched entrances rather than the customary two. Though built in 1929, a total of 25 years after the other barn, it is similar in design. (Courtesy of Missouri State Archives.)

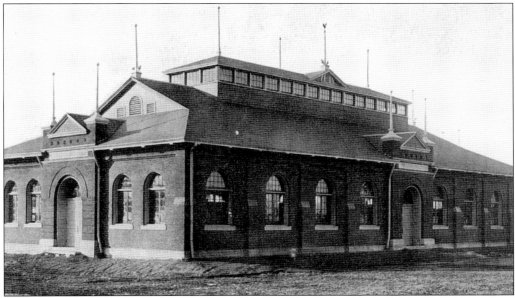

This 1903 building is another of Bast's designs. It was originally built to house poultry, but because of the scale of poultry production in Missouri it was soon outgrown. In 1905, the building was repurposed to house dairy cattle. In the 1920s, it became the University of Missouri Building. (Courtesy of Missouri State Archives.)

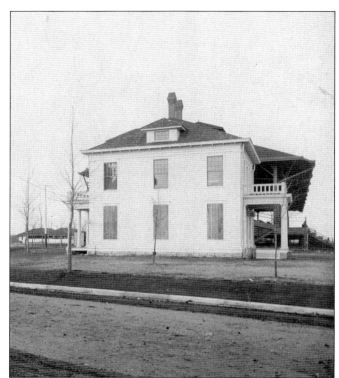

The 40-foot-by-40-foot Administration Building, erected in 1901 by Joseph Heckert and S. Wilson Ricketts at a cost of $1,876, sat just to the south of the grandstand and overlooked the racetrack. With its wide porch and balcony, it resembled a home of the era rather than an office building. This 1906 photograph shows the Administration Building, the grandstand, and what was then the Horticultural Building. (Courtesy of Sedalia Area Chamber of Commerce.)

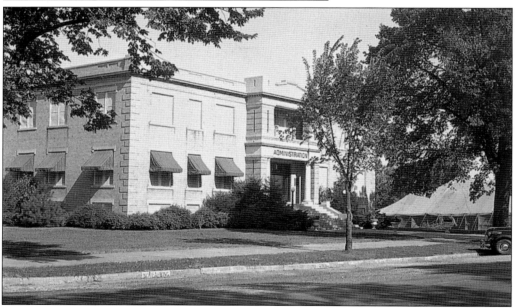

The buff-colored brick Administration Building, shown here in 1947, was constructed in 1927. Thomas Bast designed the building in a Classical Revival style, featuring a portico and balcony supported by both round and square stone columns. The building once housed a cafeteria and sleeping rooms for State Fair Board members. The administrative offices moved into the Mathewson Exhibition Center in 2001.

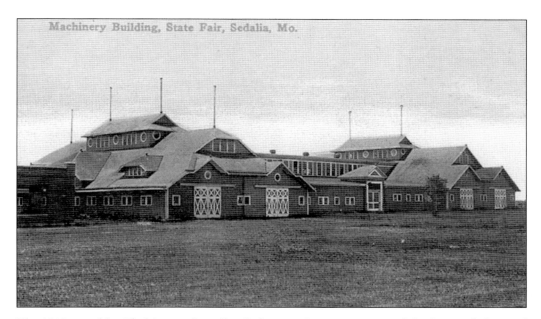

The 1903 pamphlet *The Missouri State Fair Preliminary Statement* suggested the fair needed several new structures, including an implement building where farm machinery could be displayed. The impressive frame Machinery Building (shown above) served for only a few years before 1909 when Bast designed the 120-foot-by-120-foot machinery pavilion covered with a canvas roof shown below. The machinery exhibits later moved outdoors, and the building, now with a permanent roof, became the Missouri Building in the 1920s. In the 1930s, the Machinery Building became the Poultry Building. In 1961, the ventilation structure on the roof was removed, leaving the building as it appears today. (Above, courtesy of Sedalia Public Library; below, courtesy of Missouri State Archives.)

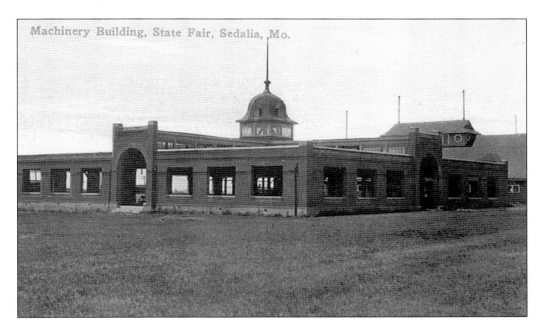

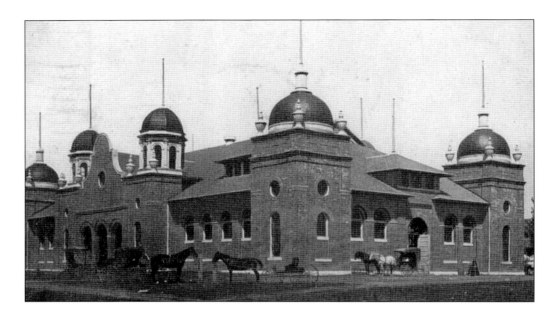

In 1903, Thomas Bast designed several brick structures to replace the frame buildings destroyed by fire; this elaborately domed building shown above in 1907 is a typical example of Bast's architectural style. The building originally featured octagonal turrets with domed roofs at each side of the two main entrances and decorative urns marking the tops of each tower. Originally designed as the Horticultural Building, by the 1920s it was known as the Varied Industries Building. By 1941, as the photograph below shows, the octagonal turrets and decorative urns had been removed, as had the decorative urns marking the corners of the towers. (Both, courtesy of Charles Wise.)

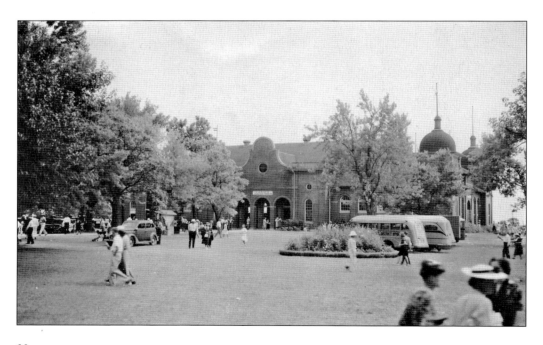

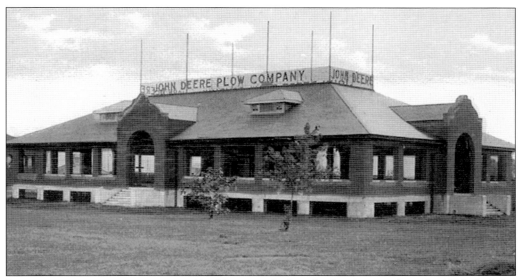

Private companies sometimes erected buildings in which to display their products. In 1909, the John Deere Plow Company hired Thomas Bast to design this brick pavilion to showcase their plows, harrows, cultivators, buggies, wagons, and gasoline engines. A two-level office and sleeping room for the building supervisor occupied the center of the structure. (Courtesy of Charles Wise.)

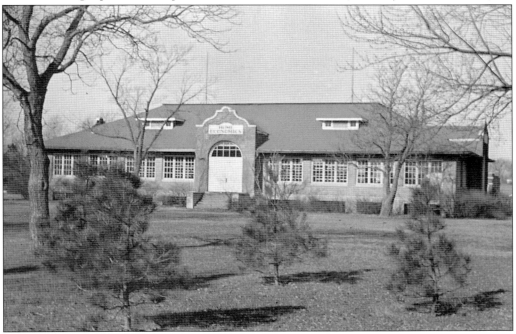

The Missouri State Fair purchased the John Deere Building in 1920 and named it for fair secretary W.D. Smith. At some point, the flat roof was replaced with a more practical hipped roof and windows added to enclose the building. In the 1920s, the building hosted the State Fair Kennel Show. In the 1930s, the structure became the Home Economics Building, used for displays of needlework and baked goods as well as demonstrations of cooking and sewing. (Courtesy of Missouri State Archives.)

The second Poultry Building (shown above) was constructed in 1905. Another one of Bast's designs, it featured alternating rectangular and circular windows and a decorative terra-cotta cartouche above the entrance. In 1935, it became the Missouri Building, housing the Missouri exhibit from the Chicago Century of Progress Exhibition. Much of the work to the facility and placing the exhibit at the fairgrounds was done by Works Progress Administration workers. In 1958, this structure became the 4-H Building. (Courtesy of Missouri State Archives.)

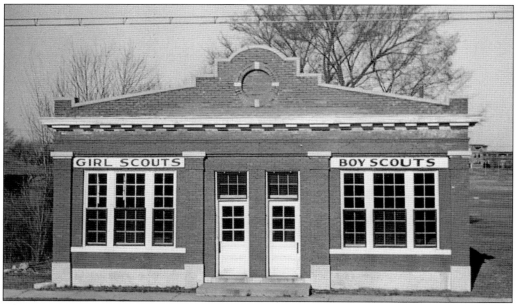

This 1913 building began as a dining hall and is now the Missouri Beef House. During the late 1940s and early 1950s, Girl Scouts and Boy Scouts displayed their work here. Following the tornado that struck the fairgrounds in 1952, Girl Scouts took damaged toys from the midway game booths to this building, where they cleaned and repaired the toys as gifts for needy children. (Courtesy of Missouri State Archives.)

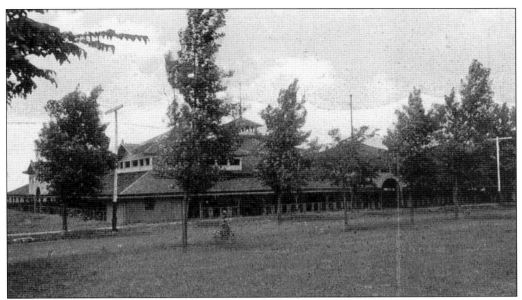

The original Swine and Sheep Pavilion (above) had 500 individual animal pens and a center show arena surrounded by raised seats for 1,200 spectators. The livestock journal *Breeders' Gazette* called it "the most imposing structure on the grounds." In 1922, Bast drew plans (shown below) for a new Swine and Sheep Pavilion. At each corner of the building, a raised tower with a pyramid-shaped roof was to house office space and sleeping rooms for the superintendents in charge of swine and sheep exhibits. The state had not appropriated enough money for its completion and had overspent on the centennial celebration at the fair the year before, so the west side of the building was not completed, giving it a somewhat truncated appearance. (Above, courtesy of Sedalia Public Library; below, courtesy of Missouri State Archives.)

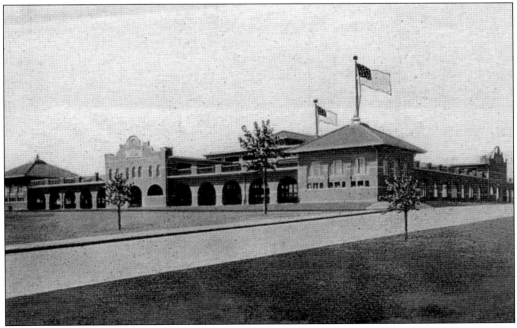

In 1907, contractor T.H. Johnson built this cattle barn designed by Thomas Bast. It features a circular window above the central entryway, which houses a small office. The round arched doors on either side of the office are typical of barns of that time. (Courtesy of Sedalia Public Library.)

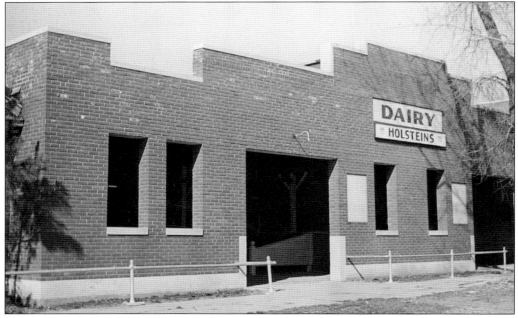

In 1926, Bast designed this rather plain barn to house dairy cattle. Sandwiched between two earlier cattle barns, it does not blend with its surroundings. (Courtesy of Missouri State Archives.)

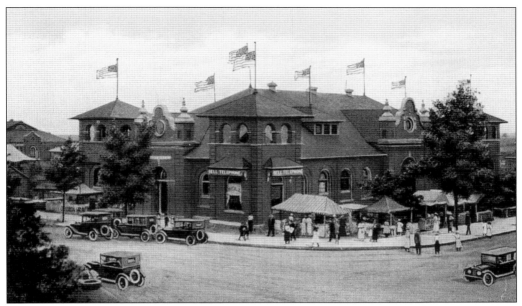

Designed by Bast in 1903, the Agriculture Building, or Horticulture Building, has corner towers resembling bell towers on Spanish missions and round arched entrances on each side of the structure. By 1917, the building was called Art Hall. Bell Telephone maintained offices there during the fair. During the 1920s, it was the Education Building, where schools demonstrated work done by their students. It is now the Commercial Building. (Courtesy of Charles Wise.)

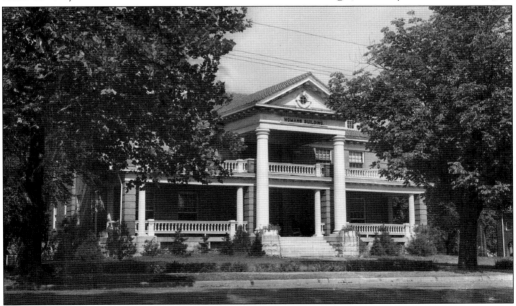

In 1910, Bast designed the Womans Building to look like a Georgian Revival–style house. The worker who produced the plaque identifying the building misspelled its name, but the plaque was never changed. The building held exhibits celebrating the achievements of Missouri women and provided a place where women could rest while at the fair. The Missouri State Fair once operated a day nursery with playground equipment where fairgoers could leave small children.

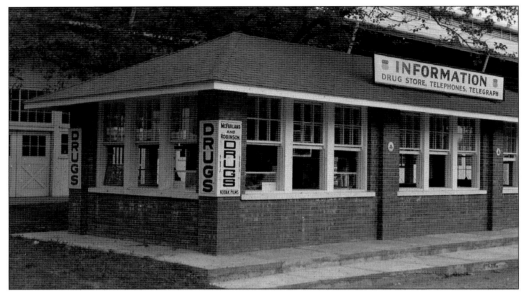

Harvey McFarland and Howard Robinson, who maintained a drugstore at 104 West Main Street in downtown Sedalia, opened a drugstore and information booth near the grandstand. This photograph from the 1940s advertises the amenities available, including telephone and telegraph services.

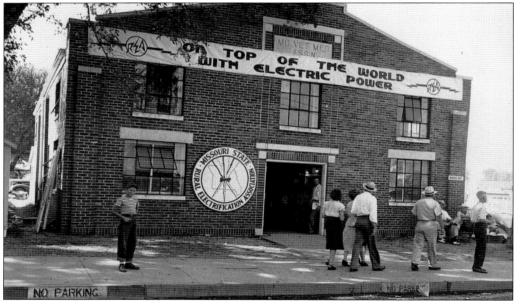

Veterinary science was a new discipline at the time of the first fair; most farmers treated sick animals themselves with a variety of home remedies and patent medicines advertised as "good for man or beast." The University of Missouri School of Veterinary Medicine began in 1884 with a single course in veterinary science that gradually expanded to become the College of Veterinary Medicine. The Missouri State Fair designated a building to highlight veterinary science. In the 1950s, the Rural Electrification Association used the building to demonstrate the advantages of electrical appliances. (Courtesy of Missouri REA.)

Three
GOING TO THE FAIR

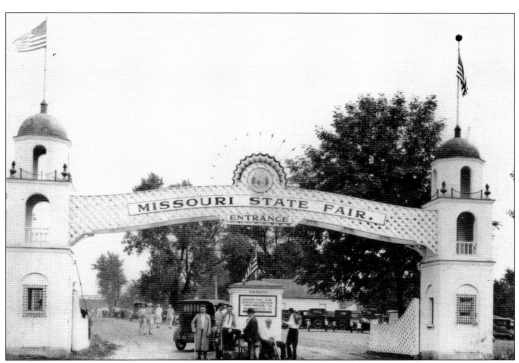

Before the first fair, Sedalia created boulevards with landscaped medians leading to the fairgrounds. The main gate of the Missouri State Fairgrounds opened onto the intersection of Sixteenth Street and State Fair Boulevard, both planted with flowers and trees. The boulevards provided an attractive, enticing approach to the fairgrounds. Thomas Bast designed the main gate in the popular Mission style with bell towers linked by a span of lattice topped with the Great Seal of the State of Missouri. The 13 arms of the sunburst above the seal represent the 13 original colonies. (Courtesy of Missouri State Archives.)

Sedalia printers Charles Botz and Sons produced this postcard extolling the variety of goods on display at the Missouri State Fair. Postcards, along with posters and premium books, provided popular, inexpensive advertising that encouraged folks to come to the fair, whether by train, trolley, or automobile. (Courtesy of Charles Wise.)

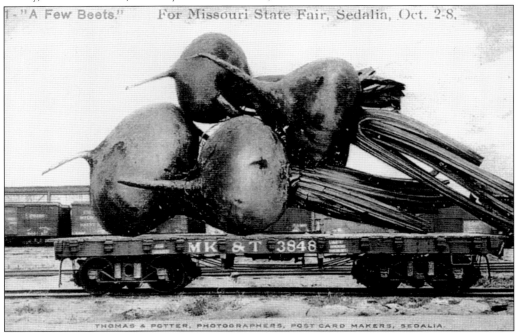

These gigantic beets bound for the Missouri State Fair on a Missouri, Kansas & Texas Railroad flatcar displayed the photographic trickery of Sedalia postcard maker Thomas Potter. Similar postcards showed cabbages, tomatoes, corn, and mules, all designed to draw attention to the productivity of Missouri gardens and farms. (Courtesy of Charles Wise.)

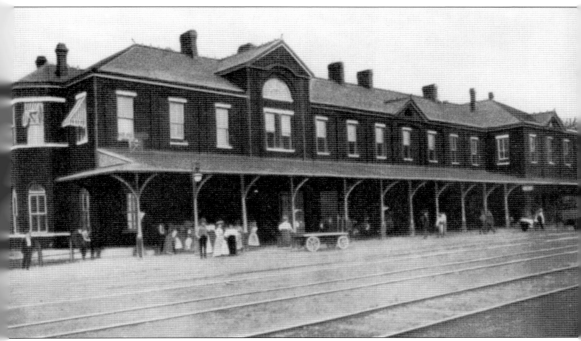

Until the 1940s, Sedalia sat at the intersection of three railroads. The Missouri Pacific Railroad, whose depot is shown here, built a spur line approximately a half-mile long from its east-west running tracks south to the fairgrounds. The railroad also built a loading platform for freight and livestock and a depot for passengers on the fairgrounds. Trains ran every 30 minutes from this depot to the fairgrounds.

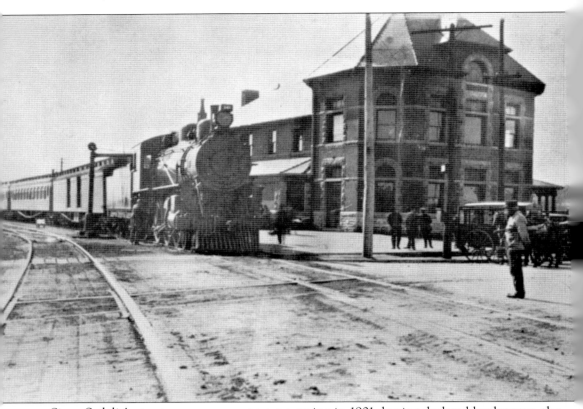

Since Sedalia's streetcar company was not running in 1901, having declared bankruptcy, the Missouri, Kansas & Texas Railroad, called the Katy, built a spur line to the fairgrounds. Sedalians could take a Katy train from this depot, built in 1896 in east Sedalia, to a depot on the fairgrounds. Trains left the depot every 30 minutes, alternating in 15-minute intervals with those leaving the Missouri Pacific depot.

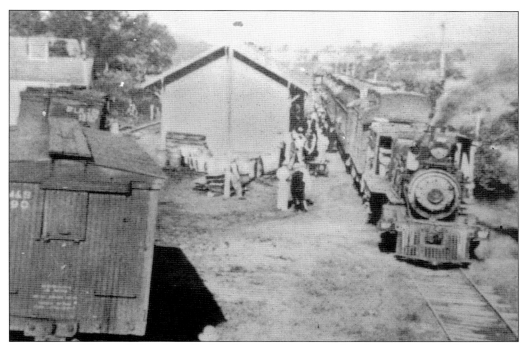

The Sedalia, Warsaw & Southern Railroad, a narrow-gauge railroad running south from Sedalia to Warsaw, Missouri, arranged special excursion trains to the Missouri State Fair. This train is leaving the Cole Camp, Missouri, depot for an early fair. (Courtesy of Ken Bird.)

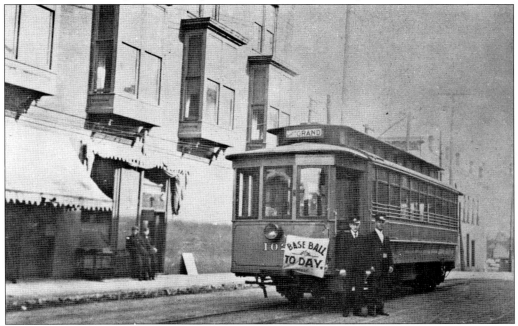

Sedalia's streetcar company, unable to provide service to the fairgrounds in 1901, was in operation again by 1902. In 1904, car No. 102 ran from Ohio Avenue in downtown Sedalia to the east side of the fairgrounds near Twentieth Street and Limit Avenue, now Highway 65.

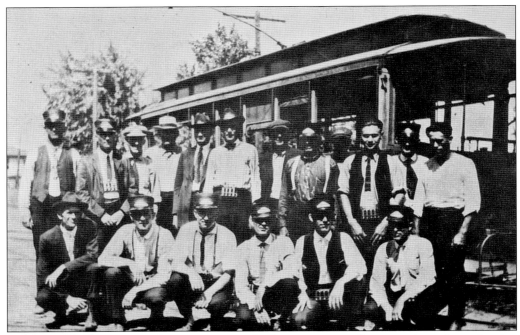

Sedalians found it easy to take a streetcar to the fair, as streetcar lines ran throughout the city. This 1920 photograph shows the 2:00 p.m. streetcar crew ready to go to the fairgrounds. A Mr. Weinrich of Marshall is the man in the suit on the first row, and a Mr. Feuers of Sedalia is in the second row. The names of the other men are not known.

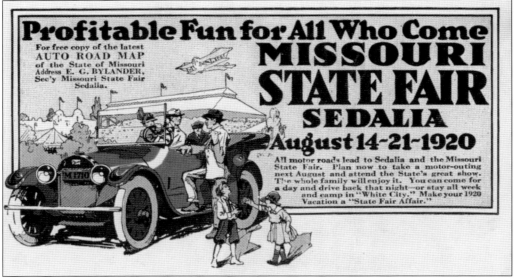

By 1917, Missouri's campaign to improve the state's roads had resulted in the completion of 11,000 miles of graded and graveled roads. The 1920 Missouri State Fair encouraged Missourians to drive to the fair by giving free road maps to those who would write fair secretary E.G. Bylander. (Courtesy of Missouri State Archives.)

In 1911, the Missouri State Fair distributed paper drinking cups as souvenirs and as reminders to come to the fair. The dates of that year's fair were printed on one side of the cups. Pres. William Howard Taft was to visit Sedalia that year as part of a 46-day tour of 26 states. While in Missouri, he planned to tour Sedalia and appear at the fair, so the slogan "everybody is coming" accompanied his picture on the other side of the cups. (Courtesy of Charles Wise.)

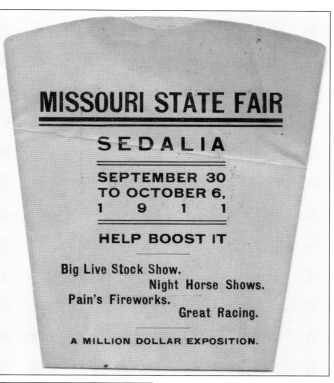

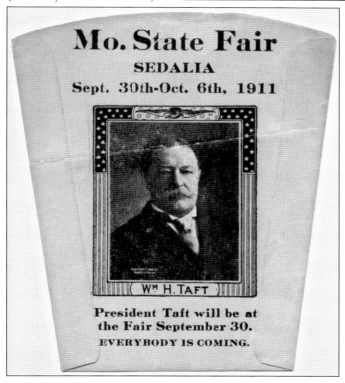

In 1917, the Missouri State Fair distributed memo books to visitors in 1917. The United States was actively involved in World War I at the time, so the fair's slogan was "Patriotism, Production, Preparedness." The inside cover of the book links Missourians' patriotism, the exhibits of crops, and livestock at the fair. (Courtesy of Charles Wise.)

In 1918, the fair continued to promote US participation in World War I with displays of US military weapons, captured weapons, demonstrations of making war bread, a replica of a YMCA recreation hut, and a dramatic reenactment of a battle with fireworks to simulate shells and bombs. (Courtesy of Missouri State Archives.)

Archias Seed and Floral Company, which began its business in Sedalia in 1884, maintained a store at 108 East Main Street and a floral shop and greenhouses at Fourth Street and Park Avenue. At the fairs of 1901, 1902, and 1903, Archias had been in charge of all the agricultural exhibits. In 1901, the company distributed this pocket card reminding fairgoers to shop at Archias while in Sedalia. (Courtesy of Ellen Weathers.)

Sedalia merchants encouraged local residents to buy products manufactured in Sedalia. They also encouraged fair visitors to shop in Sedalia. This pin announces that fair visitors could have their expenses paid if they shopped in Sedalia's stores. (Courtesy of Charles Wise.)

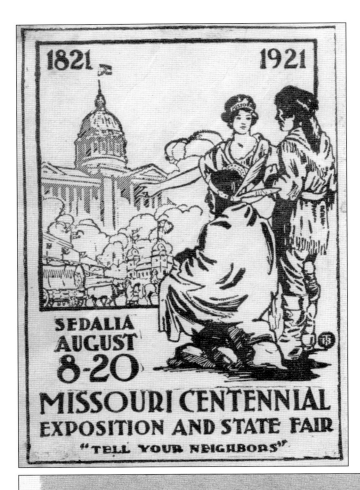

In 1921, when Missouri celebrated its centennial, the Missouri Centennial Committee advertised the state fair and the historic pageant. It was an elaborate work that lasted only two hours despite using a cast of 5,000 actors, including a children's ballet troupe, an adult dance troupe, extras playing pioneers, members of the crowds, county representatives, and soldiers. The Missouri Centennial Committee used both pocket cards (shown left) and postcards (shown below) to advertise the Centennial Fair.

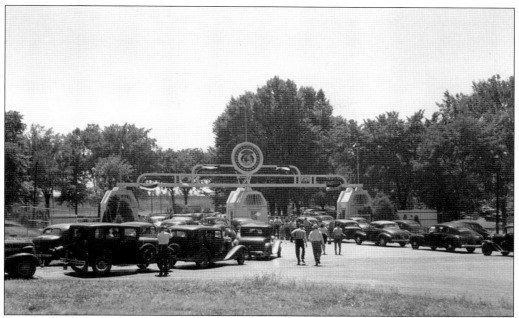

Arthur J.P. Schwartz and Harvey King designed a new and larger main gate in 1939 in the then popular Art Moderne style. The gate was larger than its predecessor and could accommodate the increased number of visitors and types of vehicles that came to the fair.

High school and college students often earned money for school by working at the fair. These two young men were photographed selling tickets at the main gate.

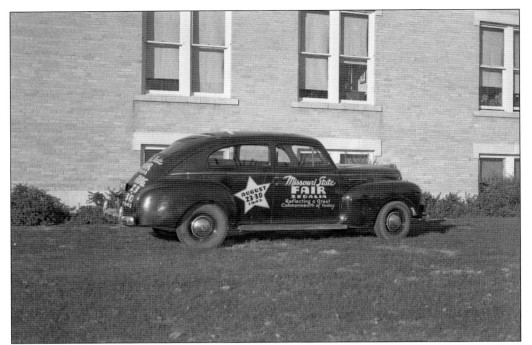

At fair time in 1942, the United States had been at war for nine months. The fair used an automobile as a means of promoting itself, but gasoline and tires were both rationed early in 1942, so the number of miles the car could travel was limited. Parked by the Administration Building, the side of the car proclaimed Missouri to be "A Great Commonwealth of Today." The rear of the car announced the dates of the fair that year.

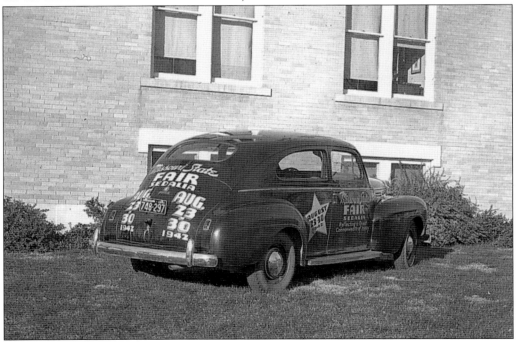

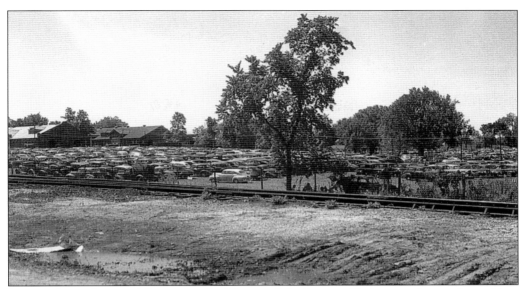

Increased use of automobiles meant the fairgrounds had to provide increased space for parking. This photograph taken for the *Sedalia Democrat* at mid-century shows hundreds of cars parked to the north of the cattle barns.

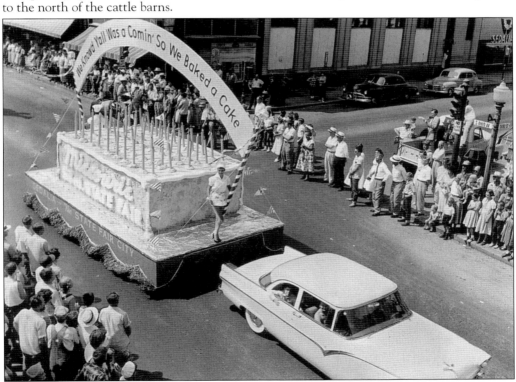

A state fair parade was a tradition during the 1950s. Crowds lined Ohio Avenue to watch during the mid-1950s. This float, pulled by a 1956 Ford, repeats the words of a popular song "If I'd Known You Were Coming, I'd Have Baked a Cake" in an ungrammatical way meant to imitate the speech patterns of rural Missouri.

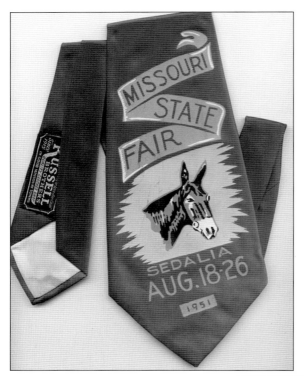

During the 1940s and 1950s, men sometimes wore neckties printed or painted with pictures of fish, animals, products, or places. This necktie from 1951, purchased at Russell Brothers Clothing Store in Sedalia, used an image of a Missouri mule to advertise that year's Missouri State Fair. (Courtesy of Charles Wise.)

As automobiles became the principle means of transportation, bumper stickers became an important way to advertise tourist destinations. In this photograph, an unidentified man distributes bumper stickers to a young fairgoer.

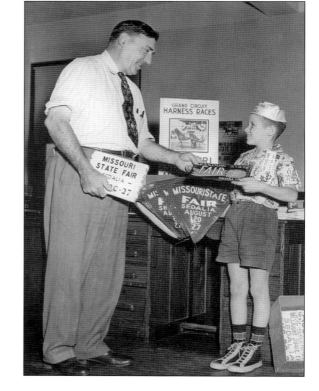

Four

Who's at the Fair?

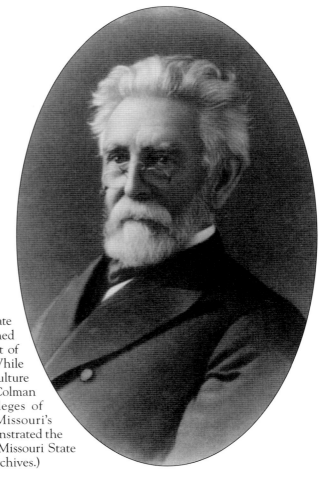

A member of the original Missouri State Fair Board, Norman Colman published *Colman's Rural World* and was part of the Missouri Board of Agriculture. While serving as US commissioner of agriculture and the US secretary of agriculture, Colman encouraged development of colleges of agriculture. The University of Missouri's agriculture experiment station demonstrated the best agricultural techniques at the Missouri State Fair. (Courtesy of Missouri State Archives.)

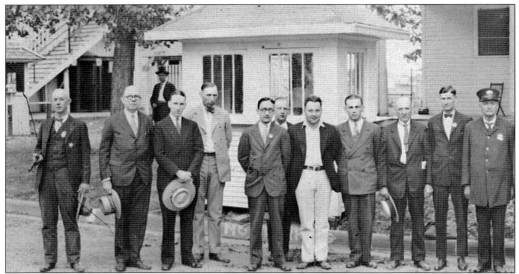

At the first fair, Sedalian Ira Hinsdale served as the chief of the fairgrounds police. Later, fairs were policed by officers and sheriffs from around the state. A group of law enforcement personnel pose in front of the Administration Building in the 1920s. (Courtesy of *Sedalia Democrat*.)

The Missouri State Highway Patrol ultimately took over policing the fairgrounds. The patrol also used the fairgrounds for training. A group of patrolmen working in front of a concession stand are photographed learning how to subdue a suspect.

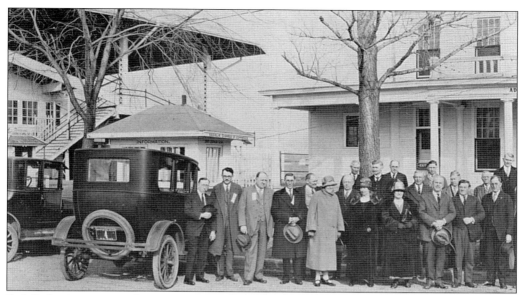

Sedalia businessmen and women supported the fair from its beginning. In the 1920s, the Sedalia Chamber of Commerce maintained an information booth next to the Administration Building on the fairgrounds. Visitors could learn not only about the fairgrounds, but also about local lodging, dining, and shopping. A group of chamber of commerce members stand in front of their booth in the 1920s. (Courtesy of *Sedalia Democrat*.)

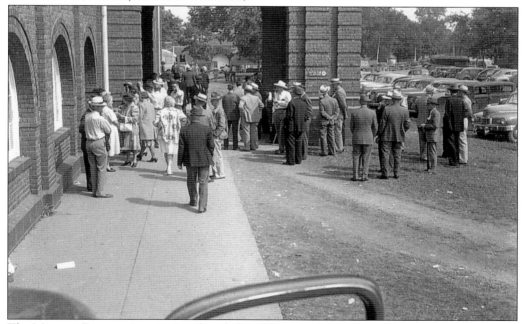

The Missouri Farmers Association, founded in 1914, joined a number of farm groups from across the state to secure economic, political, and social advantages for Missouri farmers. The Missouri Farmers Association met at the Missouri State Fairgrounds immediately after the fair. When this photograph of MFA members waiting to enter the coliseum was taken, the MFA had increased its membership to 150,000 and had become a force in Missouri agriculture and politics.

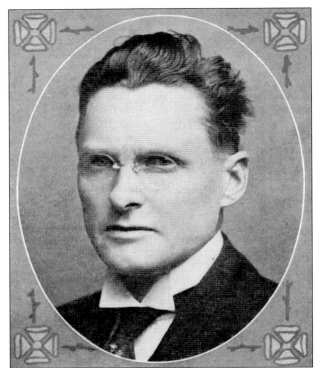

E.G. Bylander served as secretary of the fair from 1917 through 1921. Responsible for spurring the fair into patriotic fervor during World War I, he was also responsible for supervising the fair's celebration of the Missouri centennial in 1921. The centennial celebration, with its elaborate pageant, cost far more than the state had budgeted, and Bylander, a political appointee, was replaced. (Courtesy of Missouri State Fair.)

W.D. Smith served as secretary of the Missouri State Fair from 1922 through 1932. Also a political appointee, he was believed to have been dismissed from his position because he suggested the fair be canceled during the worst days of the Great Depression, although a reorganization of the fair's management by the Missouri General Assembly was more likely the reason for his dismissal. (Courtesy of Missouri State Fair.)

In 1933, the fair was made part of the Missouri Department of Agriculture. Charles Green, secretary of the fair from 1933 through 1941, faced the difficult task of organizing a fair at a time when drought hampered agricultural production and the collapsed economy caused many farmers to lose their farms. The economic situation was so severe the decision to hold a fair in 1933 was not made until May 1933. (Courtesy of Missouri State Fair.)

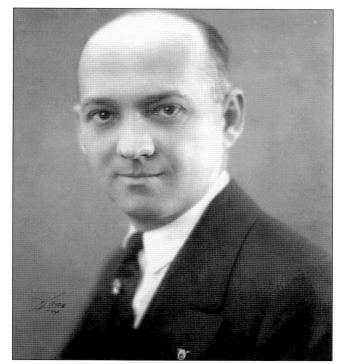

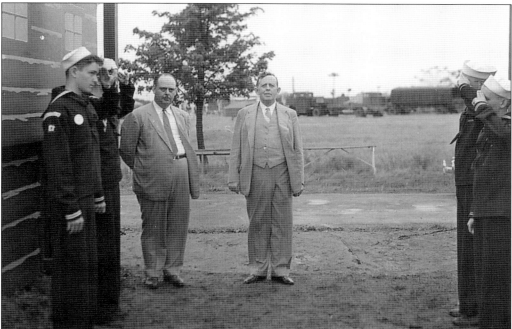

In 1942, fair secretary Ernest Baker (left), with members of the US Navy, toured the fairgrounds. The wartime fair emphasized the war effort, with marches by military men and women and a Red Cross pageant. The fair was cancelled in 1943 and 1944 due to wartime rationing and an increased home front war effort.

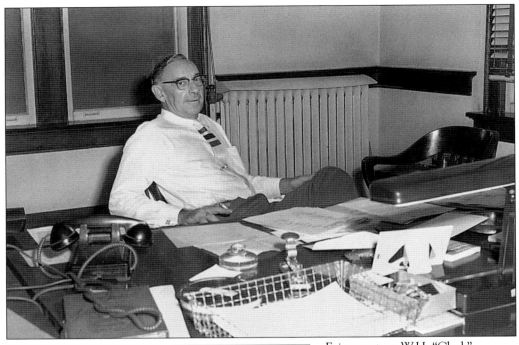

Fair secretary W.H. "Chub" Ritzenthaler replaced Ross Ewing in 1956, and also served from 1961 through 1964. Here, he takes a break from a busy day at his cluttered desk in his office in the Administration Building. (Courtesy of Missouri State Fair.)

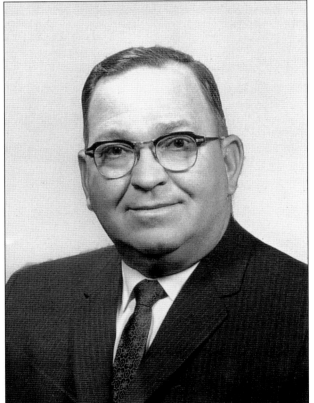

Wilbert Askew, along with cronies Mayor Julian Bagby and businessman Walter Cramer, ran Sedalia's A-B-C political machine that controlled virtually all aspects of life in Sedalia during the 1950s and 1960s. He became secretary of the fair in 1965 and continued that job until 1972. (Courtesy of Missouri State Fair.)

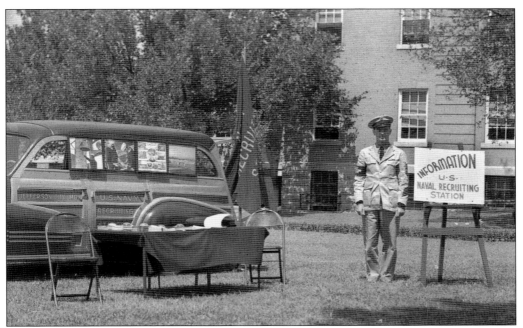

The fair serves as a venue for a variety of organizations to offer their products, services, and opportunities. Military recruiters often use the fair as a means of reaching young people. The US Navy sent a recruiter to the fair to try to interest young people in careers in the Navy.

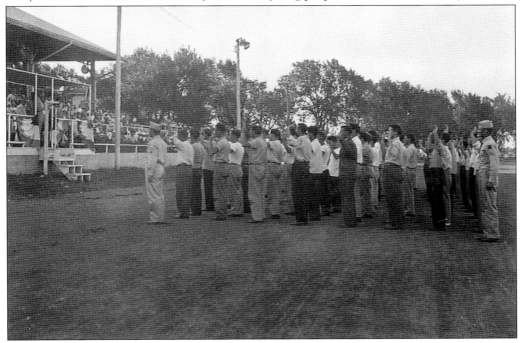

In 1946, just a year after the end of World War II, the Missouri State Fair recognized the patriotism of new military recruits by having a group of men sworn into the United States Armed Forces in front of the grandstand. The men then marched around the racetrack.

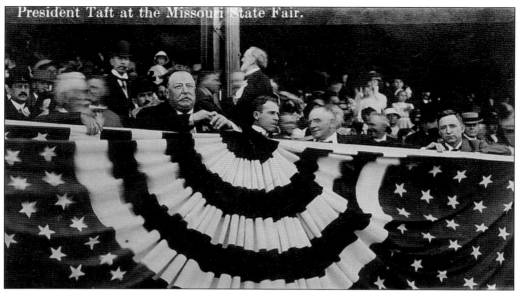

Pres. William Howard Taft visited Sedalia in 1911. He toured downtown Sedalia, met with local dignitaries, and visited the fair, where he spoke praising farmers and pushing the Payne Aldrich Tariff legislation. At the grandstand, he witnessed a parade of prizewinning livestock, an airplane exhibition, horse races, and a Presidential Mule Parade before going to the Sedalia Country Club to play golf and eat an enormous meal.

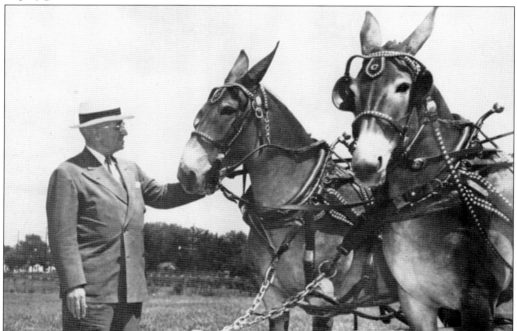

Harry S. Truman, US president from 1945 through 1952, had a long history of visits to Sedalia. He made Sedalia his senate campaign headquarters in 1940 and had often visited the fair with his family. In 1955, he returned to Sedalia and the fair where he spoke at the Ham Breakfast. Truman grew up on a farm and admired Missouri mules. (Courtesy of *Sedalia Democrat*.)

First organized in the early 20th century to teach rural youngsters how to raise livestock, produce crops, preserve fruits and vegetables, and maintain better farms and farm homes, the 4-H club has long been an integral part of the fair. Virginia Fairfax and Esther Leiter, wearing 4-H uniforms sewn by their mothers, demonstrated how to make rolls.

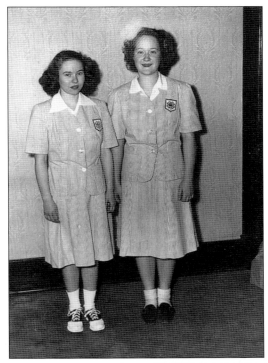

Lincoln Hubbard School in Sedalia had both a pig club and a field club. These clubs, the forerunners of 4-H clubs, taught young men the most effective methods of raising hogs and field crops. From left to right (second row) an unidentified instructor, science teacher and pig club leader Prof. Columbus Gooch, and principal C.C. Hubbard guided these young men in their projects.

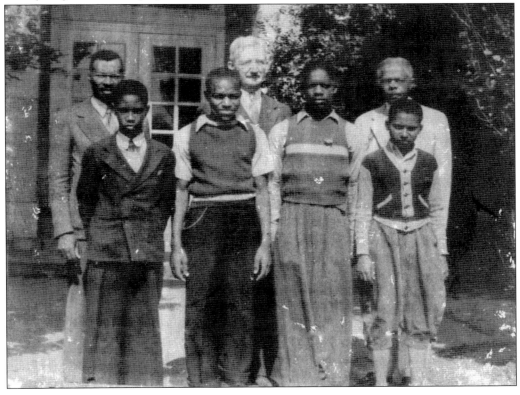

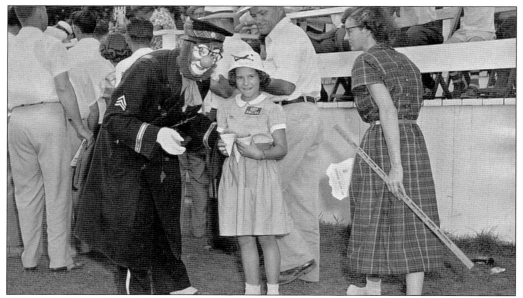

Snow cones are part of the fair, as are clowns. Here, a clown visits with a girl in the early 1953. She is wearing a "Keep Smiling" badge.

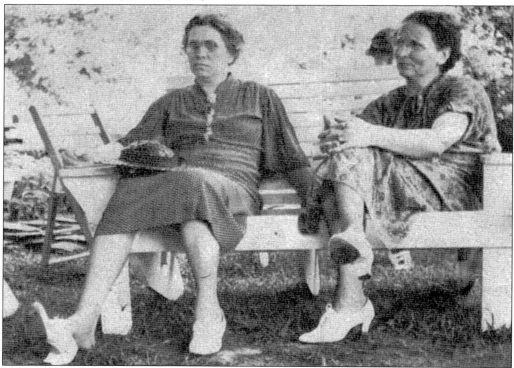

Nellie Ream and Gertrude Helman attended the Missouri State Fair. Resting after walking around the grounds in the hot weather, Nellie Ream partially removed her shoe. A photographer captured the moment and snapped a picture, which embarrassed Nellie, who believed that a lady should never remove her shoes in public. (Courtesy of Beth Palmer.)

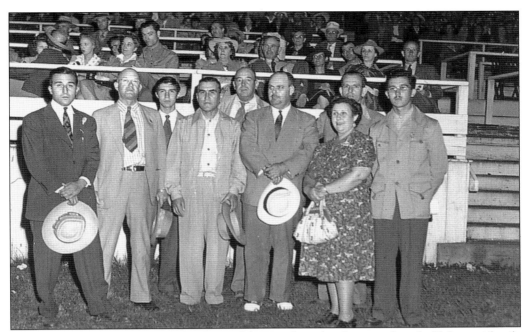

Fair secretary Ernest Baker posed in front of the grandstand with an unidentified Missouri family in the either 1942 or 1945.

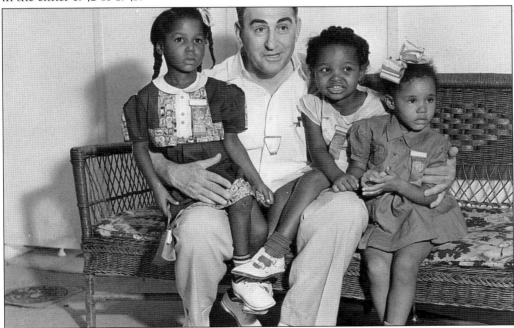

These three prizewinning girls pose with comedian Pinkie Lee after winning the Blue Ribbon Baby and Nine-Point Child Contest. These contests provided a physical examination for children, judging them on the basis of their good nutrition, dental health, immunization records, posture, and skin. African American children were judged separately from white children, and white children from rural areas were judged separately from those in small towns and those in cities.

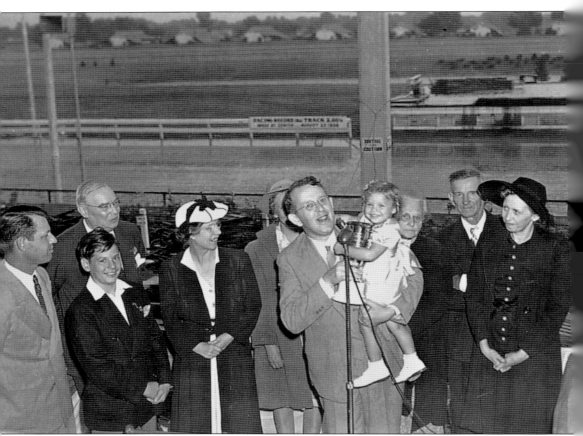

This pretty young lady gives a prizewinning smile as she clutches the trophy designating her a Blue Ribbon Baby. Fair secretary Roy Kemper, second from left, served from 1946 through 1950. He appears in the photograph with proud parents and grandparents while Gov. Forrest Donnell presents the trophy.

Five

SEEING THE SIGHTS

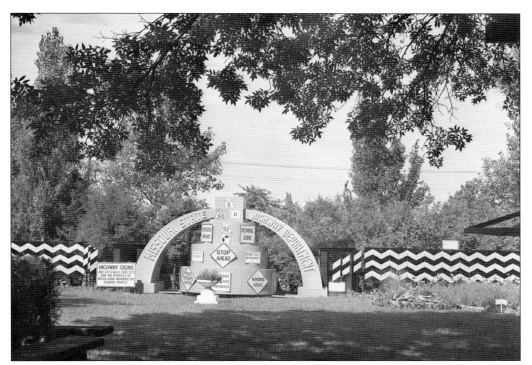

The Missouri Department of Transportation maintains the Highway Gardens, a shaded, landscaped area reminiscent of a roadside park, with shade trees, a lily pool complete with goldfish, benches, cold water fountains, and picnic tables. Over the years, the Highway Gardens has featured a grand opera house, Otto the Talking Car, a theater where puppet shows and movies about Missouri are shown, and this display explaining the types and functions of road signs.

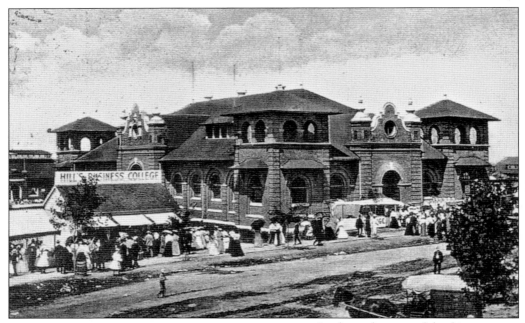

In the early years of the fair, some companies constructed their own buildings in which to display their products. Hill's Business College of Sedalia, which taught typing, shorthand, and bookkeeping, erected a small building where students demonstrated their skills. The school urged potential students to enroll with promises of good jobs awaiting graduates. (Courtesy of Charles Wise.)

Central Business College of Sedalia exhibited its students' work with demonstrations of touch typing, dictation taken at 126 words per minute, and rapid calculation. This example of artistic penmanship was typical of the work Central Business College professors and students exhibited at the fair. (Courtesy of Charles Wise.)

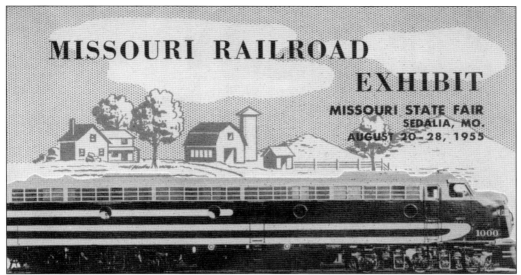

Although some railroad companies had been hurt by the Great Depression, by the 1940s a total of 30 major railroad systems served Missouri, crisscrossing the state with 7,000 miles of track. The railroads enhanced Missouri's population growth and spurred economic development. In 1955, the Missouri Railroad Exhibit distributed these pamphlets to advertise its exhibit. (Courtesy of Charles Wise.)

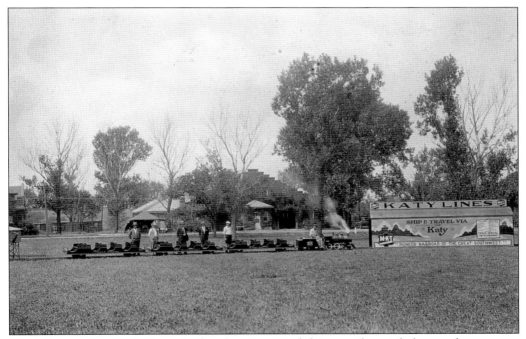

The Missouri, Kansas & Texas Railroad set up an exhibit near the cattle barns where it gave information about the Katy Railroad as well as rides in a miniature train.

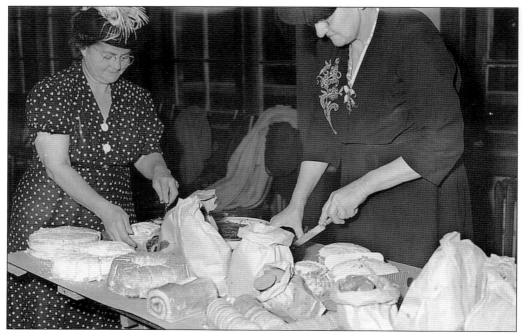

The baked goods competition tested the skills of homemakers in their ability to produce cakes, jellyrolls, and cookies. Two judges in the 1950s cut cakes prior to a taste test. The appearance of baked goods was part of the criteria for judging, so the goods were left on display for all to see.

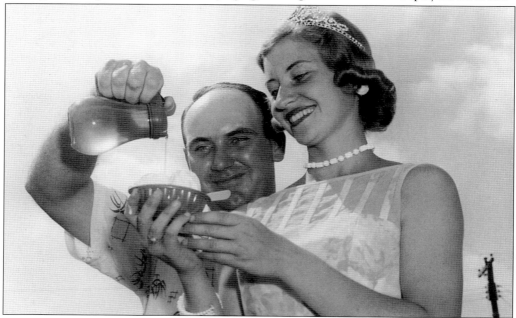

In 1902, Missouri beekeepers kept 200,000 swarms of bees and produced six million pounds of honey. Honey production increased over time and became especially important during the war years. In this photograph, Missouri State Fair queen Sharon Holt of Kennett, Missouri, accepts a drizzle of honey on a dish of ice cream.

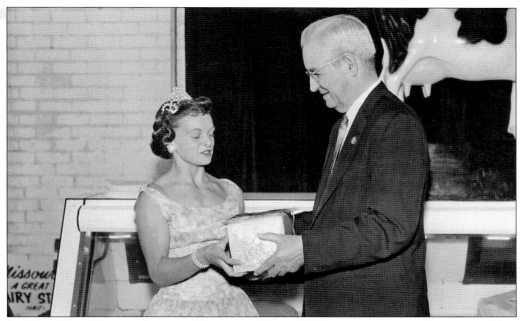

Lt. Gov. Edward Long, who served between 1957 and 1960, presents a state fair queen with a prizewinning Missouri cheese. Other cheeses are on display directly behind them. The large cow in the case at the rear of the photograph is carved from butter; the life-size butter cow was an integral part of the fair's dairy exhibit for many years.

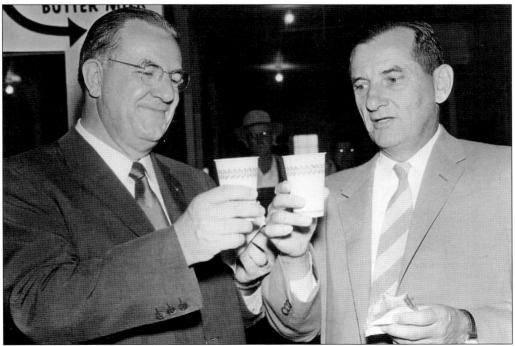

At mid-century, Missouri dairy herds consisted of more than 800,000 cows. Lt. Gov. Edward Long and a friend taste a glass of milk from Missouri's dairy herds in the late 1950s.

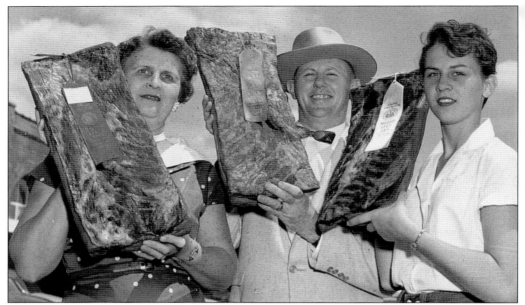

Producing good cured meats involves raising hogs with an appropriate fat to lean meat ratio, seasoning and curing the meat properly. Meat processors display the best of Missouri's slabs of cured bacon.

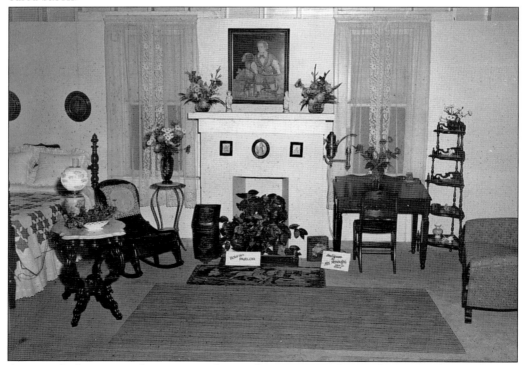

Antiques had constituted a category of entry for many years, but in the 1940s, the fair decided to limit antique displays to those by dealers. This display of Victorian furniture arranged in an attractive room shows the work of a Mrs. Menaugh of Sedalia.

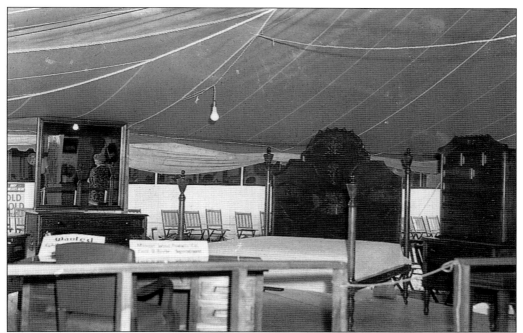

Furniture makers show their goods, ranging from utilitarian desks and office chairs to ornately carved beds and a dresser, in a display of Missouri wood products. The exhibit is in a tent, perhaps not the best place given the vagaries of Missouri weather.

Thrifty women have recycled feed and flour sacks into aprons, children's clothes, quilts, and garments since the cotton feed sack was introduced in the late 1800s. During the Great Depression, the use of feed sacks increased as women were unable to afford fabric. In 1936, the Staley Milling Company of Kansas City, Missouri, offered additional prizes to women who used Staley Tint-Sax for their entries to the sewing competition. (Courtesy of Missouri State Fair.)

174 *The 42nd Annual Missouri State Fair*

$270.00
IN CASH PRIZES

Ladies, if you are going to enter some of your hand work and sewing at the Missouri State Fair, it may pay you to make whatever you intend to enter from

STALEY'S TINT-SAX

The Staley Milling Company offers cash prizes of $10.00 to the winner of First Prize, $7.50 to the winner of Second Prize, and $5.00 to the winner of Third Prize, provided the prize-winning article is made from TINT-SAX in the following lots:

 LOT 145—CHILDREN'S CLOTHING (3 to 12 Years)
 LOT 146—WOMEN'S CLOTHING, and
 LOT 150—YOUNG WOMEN'S WORK (Age 13 to 16)

Look elsewhere in this premium book under the above lot numbers for the various classifications in which these valuable Staley cash prizes are offered.

NOTICE: These Staley cash prizes are offered in addition to the regular prizes listed in this premium book. The same rules established by the Missouri State Fair shall apply in all cases, and the decision of the regular judges shall be final.

Staley will supply free on request Tint-Sax labels for attaching to articles for the purpose of aiding judges in quickly identifying articles made from Tint-Sax.

TINT-SAX are quality, colored cambric bags from which women make hundreds of attractive, useful articles—aprons, dresses, luncheon sets, table cloths, curtains, quilt blocks, etc. Tint-Sax come in a variety of attractive colors. The Staley label washes out easily, leaving the fine quality material practically unmarred and ready for use.

STALEY FEEDS for Chickens, Turkeys and Hogs are packed in Tint-Sax. These feeds are well known for their fine quality and successful results which they help users to attain. They are reasonably priced. See your nearest Staley Feed Dealer or write direct.

STALEY MILLING COMPANY
KANSAS CITY, MISSOURI

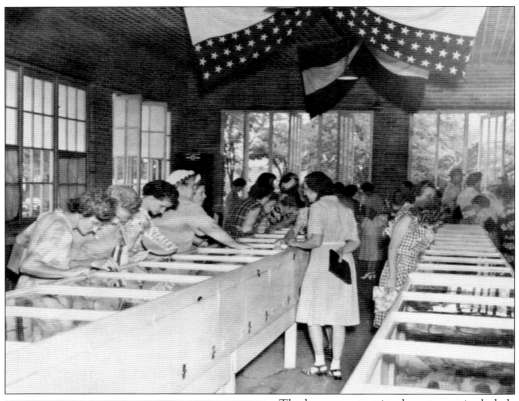

The home economics department included competition for baked goods, canned vegetables, preserved fruits, embroidery, knitted and crocheted items, quilts, and clothing. Women examine the goods on display in the Home Economics Building. (Courtesy of Missouri State Archives.)

The Missouri Federation of Garden Clubs works with the horticulture department and offers prizes for the best arrangements reflecting a specific theme. An unidentified sweepstakes winner poses with her arrangement.

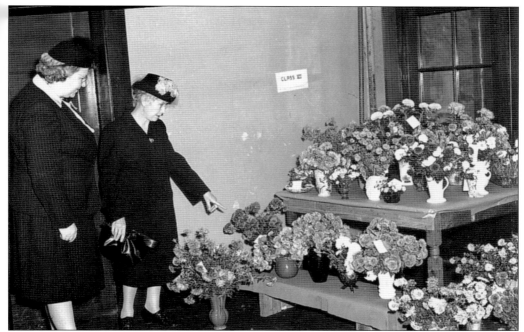

Specific types of flowers are judged according to standards set by horticulturalists. Entrants gather the best from their plants for display. Here, judges examine vases of flowers, possibly dianthus.

Industrial arts programs came to Missouri schools in the early 20th century as a way of providing factories with a skilled workforce. At mid-century, the Eldon Schools displayed their students' woodworking, machining, and welding.

The Missouri Congress of Parents and Teachers Association sought to bring parents and teachers together to provide better education. The PTA lobbied for political change that would benefit schools.

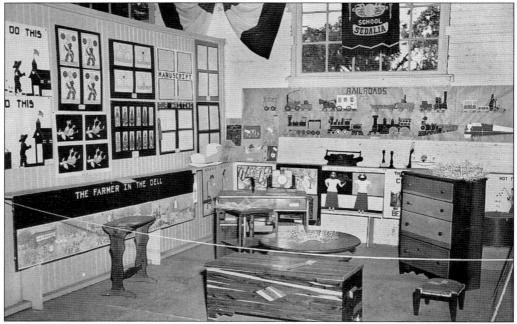

Lincoln-Hubbard School in Sedalia provided elementary education to African American children in Sedalia and high school education for students from a five county area prior to implementation of *Brown v. Board of Education*. This display highlights the work done by their students from first grade through high school. (Courtesy of Missouri State Archives.)

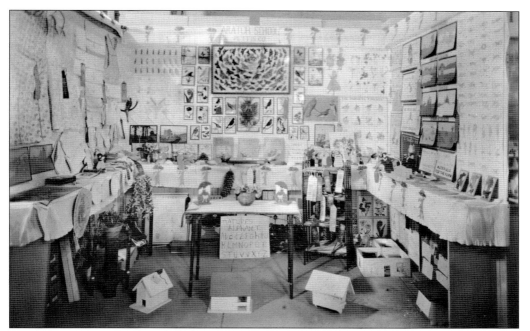

Rural elementary schools included nature study, beginning woodworking, and sewing classes in their curriculum. Arator School, a rural elementary school northeast of Sedalia taught by Gladys Ferguson, won a number of ribbons for its students' work at the fair in 1931.

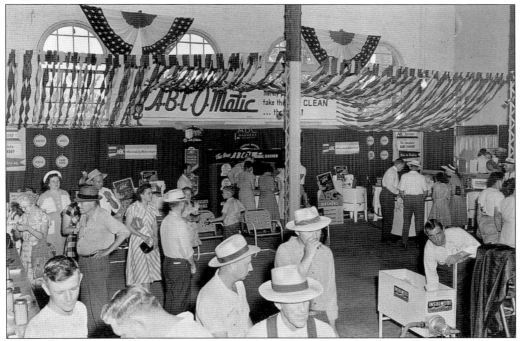

The ABC-O-Matic Washing Machine Company began making washing machines as the Altorfer Brothers Company in Peoria, Illinois. In the 1940s, they showed their wringer washers at the Missouri State Fair.

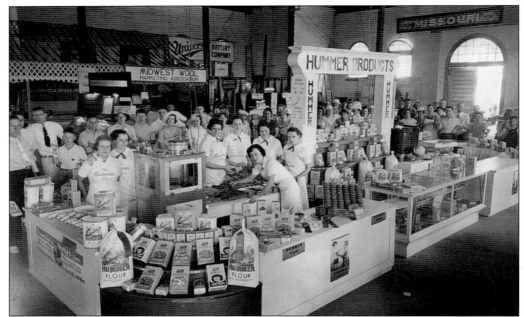

This photograph displays the stained-glass sign from the Missouri Building of the world's fair above the door. The Universal Battery Company and Midwest Wool Marketing Association have displays. The largest display is that of the Hummer Products, which is staffed with uniformed home economists demonstrating the fine qualities of Hummer flour.

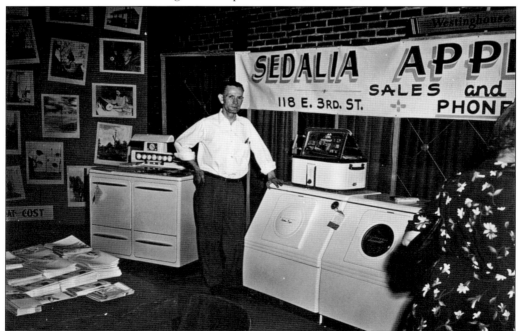

A representative of Sedalia Appliance, located at 118 East Third Street in Sedalia, showed this washing machine and automatic dryer at the Rural Electrification Association Building. (Courtesy of Missouri REA.)

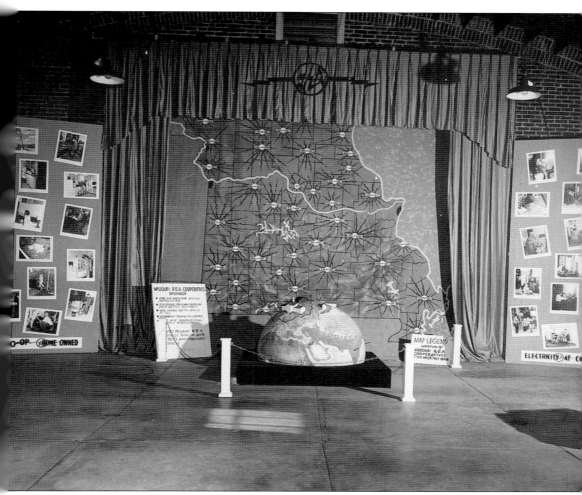

In 1930, only 10 percent of rural homes had electric service. The Rural Electrification Association, established by Congress in 1935, provided electric power for farms and homes. The REA used the former Veterinary Building on the fairgrounds to highlight its work. This map shows the locations of REA centers in Missouri. (Courtesy of Missouri REA.)

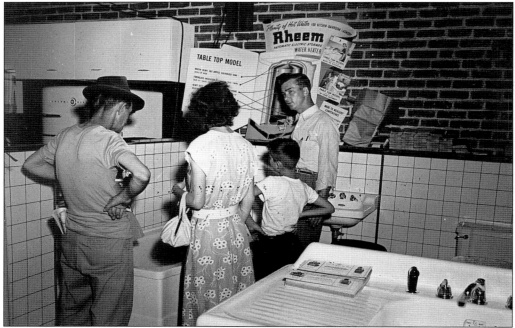

Electric-powered appliances were shown as early as the 1903 world's fair but did not become practical or affordable until the 1940s. In the 1950s, some rural homes still lacked indoor plumbing. This display shows tubs and sinks as well as Rheem hot water heaters to a family interested in upgrading their home. (Courtesy of Missouri REA.)

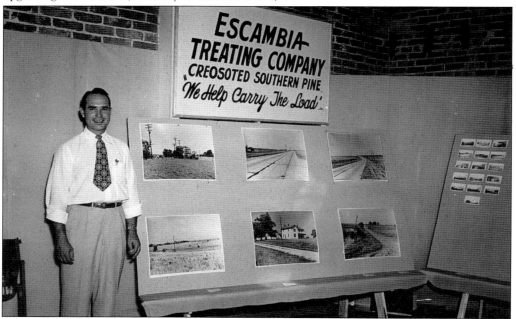

In the early years of the 20th century, people in rural areas who wanted telephone or electrical service often had to provide the poles on which the lines were run. The Escambia Company marketed treated pine poles with this display. (Courtesy of Missouri REA.)

Six
Fresh off the Farm

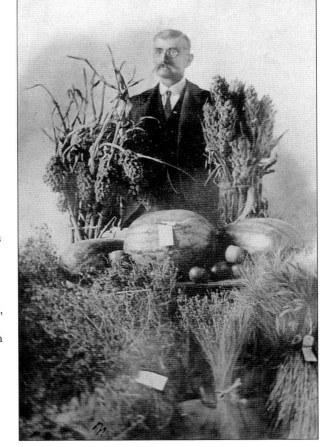

In the early 20th century, Missouri's primary field crops were corn, wheat, oats, sorghum, cowpeas, rye, alfalfa, and a variety of grasses used for hay. Popular fruit and vegetables included potatoes, onions, tomatoes, beans, apples, watermelons, peaches, and grapes. The gentleman posing with his prizewinning crop is identified as a Mr. Barnett or Basnett; the identification on the back of the photograph is difficult to read. He produced a crop typical of a Missouri farm at the time. (Courtesy of Charles Wise.)

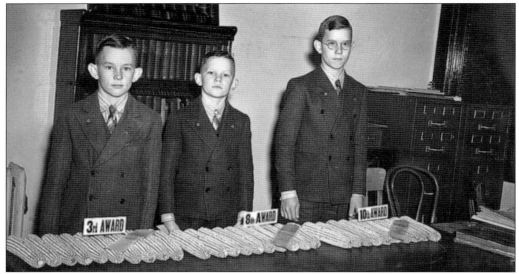

Boys often participated in Corn Clubs, a forerunner of 4-H that involved a boy following the most up-to-date methods to select a plot of ground, plant corn, and raise and harvest the crop. These three boys, who appear to be brothers, have successfully produced their crops, winning the third, eighth, and 10th awards for their crops. They are shown with their ribbons in the Administration Building.

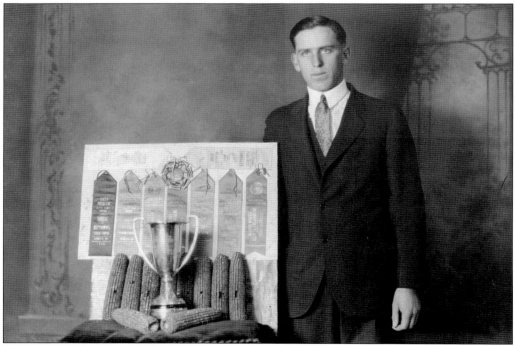

The University of Missouri Farm Agents sponsored corn schools that taught the best methods of producing corn to farmers throughout the state. They also sponsored contests, hoping that competition would encourage farmers to work harder to make a larger crop. This photograph shows the winner of a Pettis County Seed Corn Contest.

University of Missouri Extension agents, such as C.M. Long, who served the Pettis County Bureau of Agriculture in 1917, worked with farmers to help them improve their crops by teaching evening classes in liming soils, fertilization of wheat, and preventing soil erosion. When J.D. Smith printed *Souvenir: Missouri State Fair, 1917,* a 58-page book describing Pettis County, he included a page describing Long's work and showing the photograph below of a field contour plowed to prevent erosion.

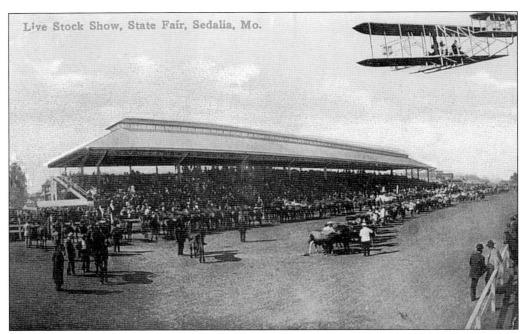

Livestock were paraded around the racetrack, allowing those in the grandstand to see. It is unlikely that the airplane is flying over the grandstand at the time of the livestock parade; instead, the image of an airplane has been superimposed onto the photograph of the grandstand in order to impress people with the up-to-date nature of the fair. (Courtesy of Charles Wise.)

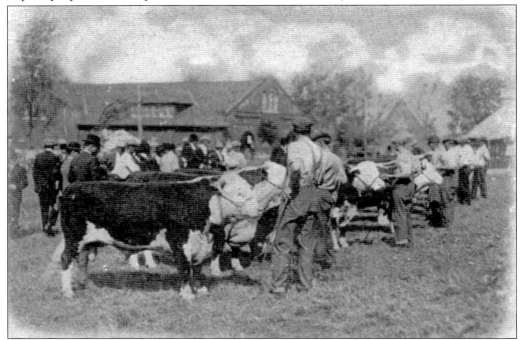

Souvenir: Missouri State Fair, 1917 featured this group of stockmen with their cattle being scrutinized by judges and other stockmen in front of the cattle barns in 1916.

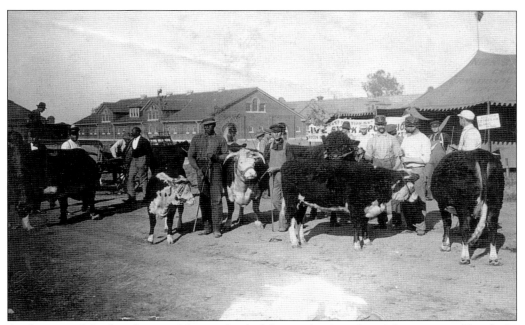

At the time of the first fair, roughly one-third of the purebred cattle in Missouri were Herefords. Missouri Herefords regularly won championships at various world's fairs and other state fairs. The breed continued to be popular among Missouri stockmen. This Hereford won at a Missouri State Fair in the late 1940s or 1950s.

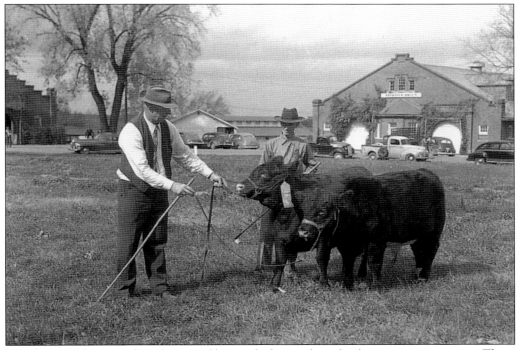

The fairgrounds were often the site of livestock shows when the fair was not in session. These prizewinning polled Shorthorn cattle were part of a Shorthorn show in 1955.

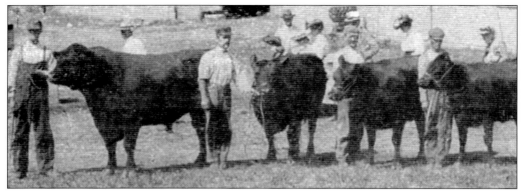

Aberdeen Angus cattle originated in Scotland and were first brought to the United States in 1873 when George Grant brought four Angus bulls to Kansas. Within 30 years, the breed was established as a vigorous producer of beef. Carroll County stockmen, such as W.J. Turpin, whose animals are shown here, was one of Missouri's premier breeders of Angus cattle.

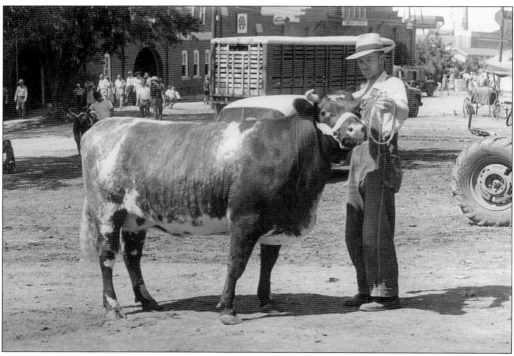

At the time of the first fair, Shorthorn cattle made up half of the 50,000 purebred cattle in Missouri, but by the 1940s, the number of Shorthorn cattle had declined somewhat. Shorthorns still showed at the fair. This farmer passes trailers and tractors as he leads his Shorthorn cow across the road from the cattle barns to the coliseum for judging in 1957.

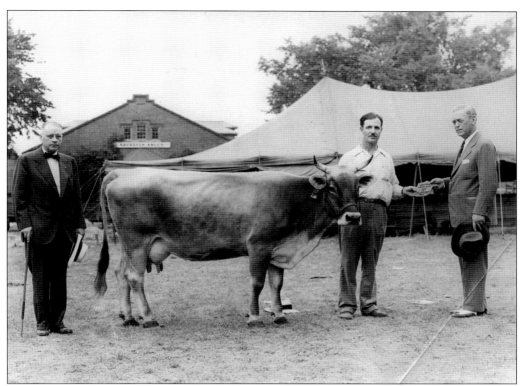

Dairy cows are judged on the quantity of milk they produce and the percentage of butterfat in the milk. A cow entered in the fair had to have produced a calf within 12 months of the fair. Stockmen were not allowed to prepare their animals other than by cleaning them, brushing their coats, and polishing their hoofs. This cow was the champion dairy cow in the late 1940s.

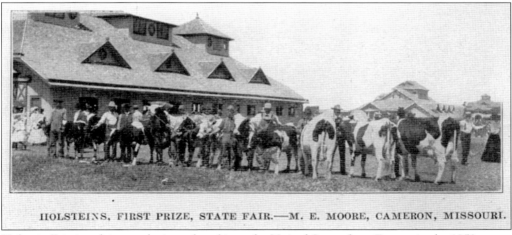

Holstein-Friesian dairy cattle, introduced into the United States from Europe in the 1850s, were slowly becoming a popular breed at the turn of the century. M.E. Moore of Cameron, Missouri, exhibited this prizewinning herd of Holsteins at one of the first fairs.

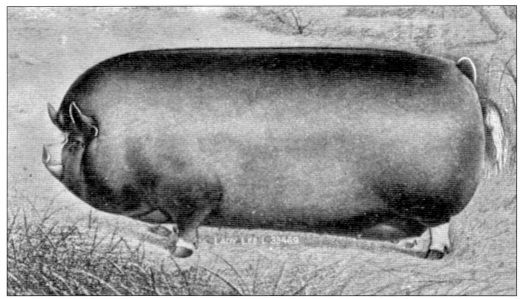

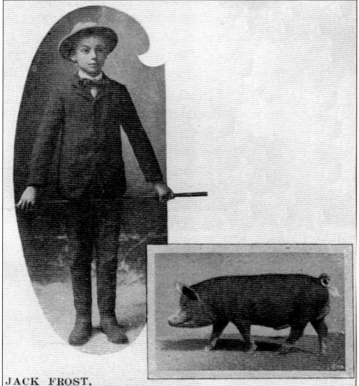

JACK FROST, YOUNGEST MISSOURI BREEDER, WITH KING TOM, FIRST PRIZE BERKSHIRE UNDER SIX MONTHS, STATE FAIR.

Berkshire hogs were one of the three most commonly raised hogs in Missouri at the time of the first fair. Breeder Nicholas Gentry maintained a large farm in Pettis County where he bred prizewinning Berkshire hogs. He was named to the prestigious Saddle and Sirloin Club because of the quality of his animals, which by 1903 were part of the bloodlines of most purebred Berkshire herds in the nation. A drawing of his hog Lady Lee L. 33,469 is shown here. The youngest breeder of Berkshire hogs to exhibit at early fairs, Jack Frost is shown here with King Tom, the Berkshire hog that won first prize in the "under six months" class at a fair prior to 1904. The drawing shows an idealized version of a hog; the photograph shows the animal as it actually appeared.

Hampshire hogs, recognizable by the white band that surrounds their bodies, were originally called Thin Rind hogs. At the first fairs, they constituted only a small percentage of the hogs on display. W.F. Davies, whose stock is shown here, was a noted breeder of Hampshires, which became increasingly popular in the Midwest after 1910. By mid-century, the demand for Hampshire hogs as breeding stock and as meat animals continued to increase. This dapper gentleman at right is showing a Hampshire sow at a fair in the late 1940s.

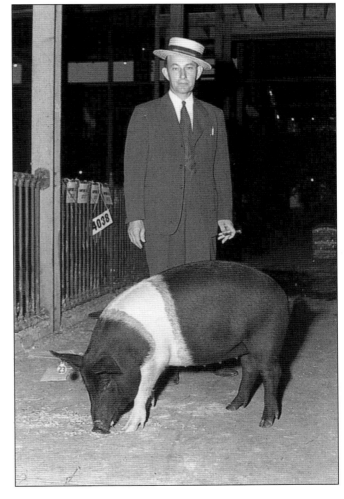

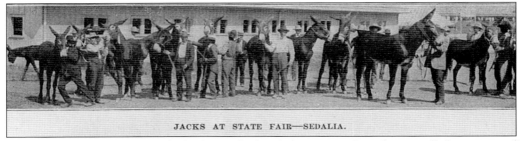

JACKS AT STATE FAIR—SEDALIA.

A mule is a cross between a male donkey and a female horse. Female mules are called jennies, and male mules are called jacks. These jacks are shown with their handlers at an early fair against a background of the exhibition horse and mule barn.

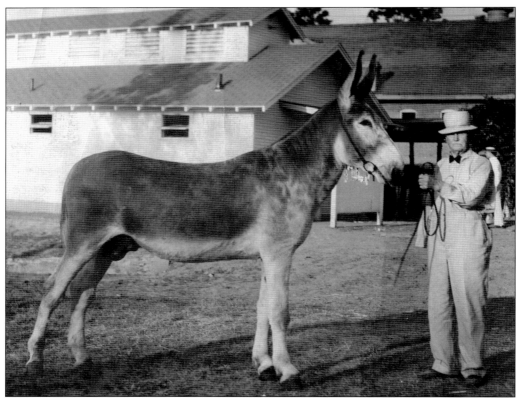

Pettis Countian Lewis Monsees, a world renowned breeder of mules, won grand prizes with his stock at the Chicago and St. Louis World's Fairs, at the Pan-American exhibition in San Francisco, and at the Missouri State Fair. He appears here with one of his mules at the Missouri State Fair in the 1940s.

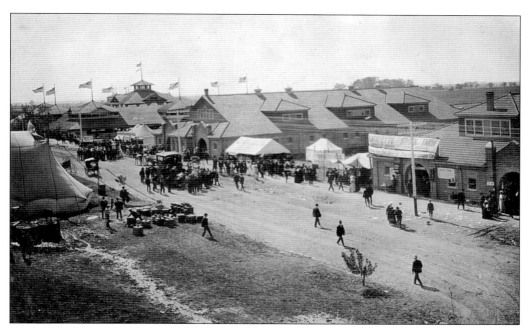

At the first fair, one of the cattle barns housed horticulture and field crop exhibits. By 1903, the fair had constructed a building for displays of crops as well as several more livestock barns. The Lafayette Stock Farm stretched a banner across the front of the barn where its stock was exhibited. (Courtesy of Charles Wise.)

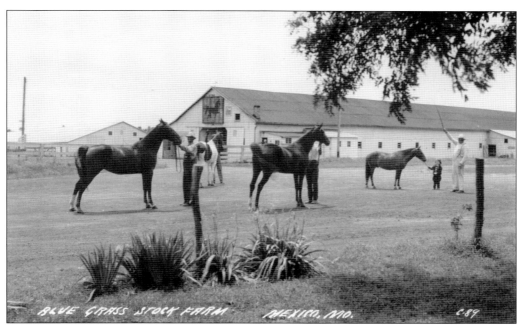

The Blue Grass Stock Farm in Mexico, Missouri, often exhibited at the fair. Here, grooms bring three horses for inspection at the farm in Mexico.

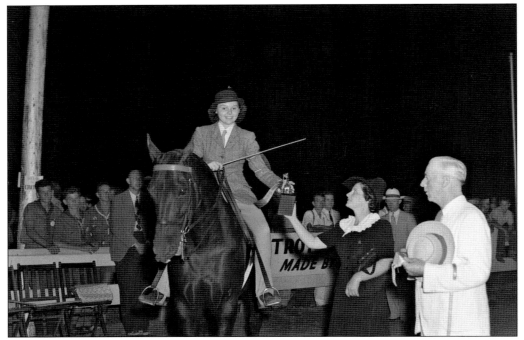

Participants in horse shows are held to high standards of dress and behavior, and their horses are held to high standards of confirmation and behavior. Horses are expected to demonstrate good mannerisms in a variety of gaits, shift smoothly from one gait to another, and stand quietly while a judge inspects them. The Boy Scouts in the background of the photograph seem more interested in looking at the smiling prizewinner than at the horse.

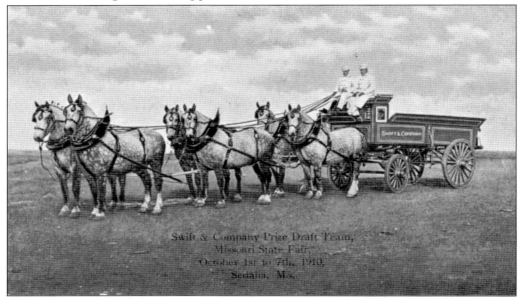

Draft horses are large horses bred to pull heavy wagons. These Percherons in a six-horse hitch pulled a red wagon with gilded trim for Swift and Co. In 1910, they were a prizewinning team at the fair. (Courtesy of Charles Wise.)

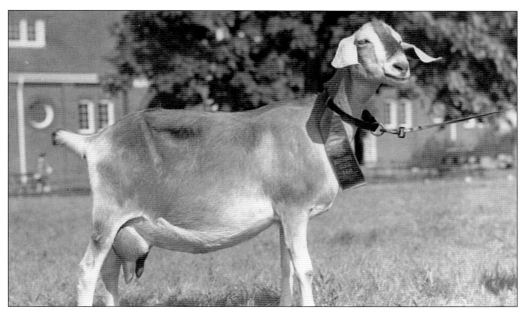

Although dairy goats constitute only a small part of Missouri livestock herds, they have been shown at the fair since the beginning. Goat's milk is considered especially healthy and can often be used by those who cannot tolerate cow's milk. This Nubian goat shows the characteristics expected of a prizewinning member of the breed.

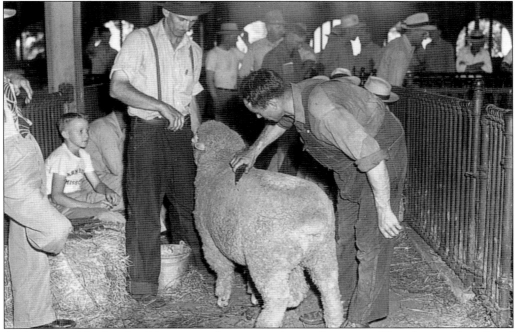

At the time of the first fair, Missouri stockmen owned more than one million sheep and produced more than four million pounds of wool annually. Although the number of sheep breeders in Missouri has declined, sheep continued to constitute an important part of the fair. These farmers at the fair in the 1950s groom a ram before showing him.

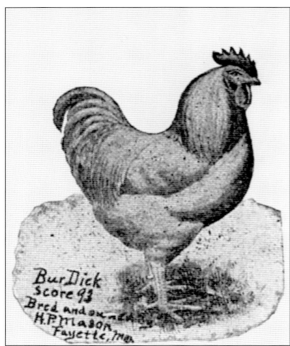

In 1900, Missouri produced $14 million worth of poultry and poultry products, such as eggs and down, making it the nation's number one producer of poultry. Nearly every farm and many suburban homes had a small of flock of chickens, ducks, and geese. Women often produced poultry for commercial as well as domestic markets. Popular breeds included Plymouth Rock and Buff Rock. This drawing shows a prizewinning chicken from Fayette. (Courtesy of Missouri State Archives.)

By the 1950s, poultry raising had become more commercialized. Poultry exhibits at the fair included examinations of carcasses to evaluate the quality of meat produced. These chicken carcasses are dressed New York style, which means their feet are still attached.

Seven
FOR THE FARM

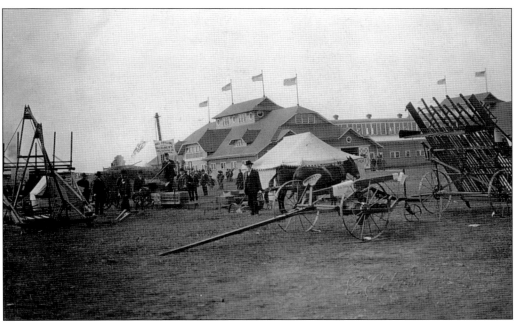

The turn of the 20th century marked the beginning of a mechanical revolution in agriculture. Tractors had been developed, and at early fairs, steam- and gasoline-powered tractors were exhibited. However, early tractors were not entirely practical, so horse- and mule-drawn farm implements were still the norm. Implements were displayed inside the Machinery Building in the background, or on the lawn. A pair of horses are harnessed and ready to demonstrate the horse-drawn machinery. Visitors examine a horse-drawn cradler and well-drilling equipment. (Courtesy of Charles Wise.)

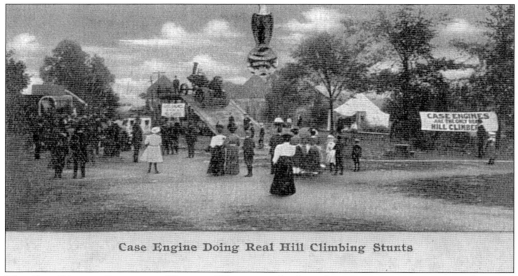

Case Engine Doing Real Hill Climbing Stunts

The Case Tractor Company of Racine, Wisconsin, built its first farm tractor in 1892. The word *tractor* derives from *traction* and refers to the tractor's ability to traverse uneven ground. Fair visitors of all ages watch the Case Tractor demonstrate its ability to climb hills. (Courtesy of Charles Wise.)

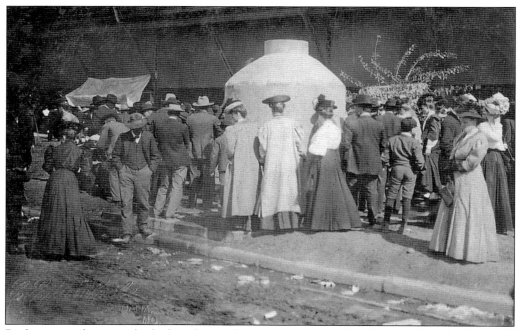

Both men and women looked at the machinery displayed under the grandstand at an early fair. Here, they are drinking cool water from the large circular water cooler in the center of the photograph. (Courtesy of Charles Wise.)

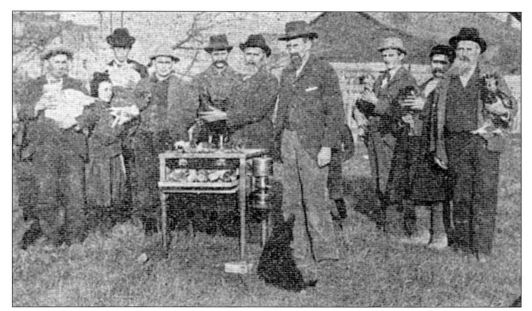

The Sure Hatch Incubator Company of Clay Center, Nebraska, published a catalog each year that contained nearly 100 tips on poultry raising. Visitors could examine the Sure Hatch Incubator and pick up a catalogue at the first fair in 1901. (Courtesy of Missouri State Fair.)

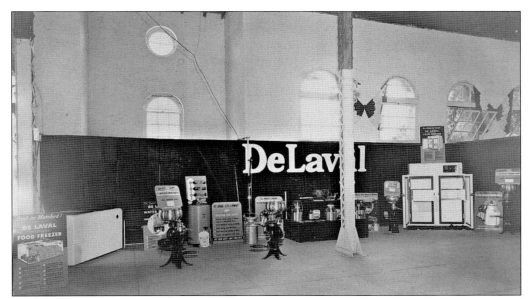

The DeLaval Company manufactured a variety of appliances, including food freezers and refrigerators, but it is perhaps best known for the cream separator, a device to separate cream from fresh milk. De Laval had its exhibit inside the Varied Industries Building.

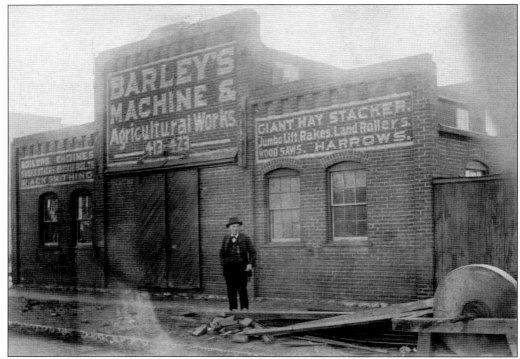

Thomas K. Barley opened an agricultural machinery manufacturing company at 417 West Main Street in 1882. An inventor as well as a manufacturer, he designed and built hay rakes, stackers, and loaders, in addition to doing sheet metal and machine work and selling steam and gasoline engines. *Souvenir: Missouri State Fair, 1917* printed this photograph of Barley's Machine & Agricultural Works factory in Sedalia.

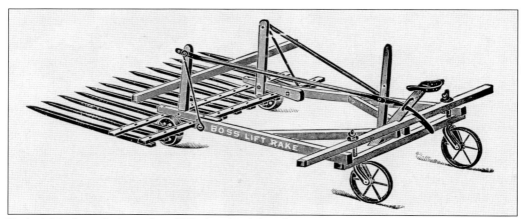

Barley's Machine & Agricultural Works of Sedalia advertised this piece of equipment in *Souvenir: Missouri State Fair, 1917*. The hay rake with a short turning radius, high wheels, and steel-pointed teeth was valued for its ability to traverse uneven ground.

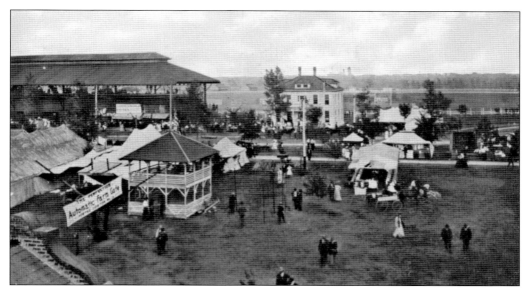

In 1910, some machinery was displayed west of the Administration Building and grandstand. A Perfection Automatic Farm Gate is shown on the left. Clemons Honcamp, a Sedalia cigar manufacturer, exhibits and sells his work in a stand under the grandstand. (Courtesy of Charles Wise.)

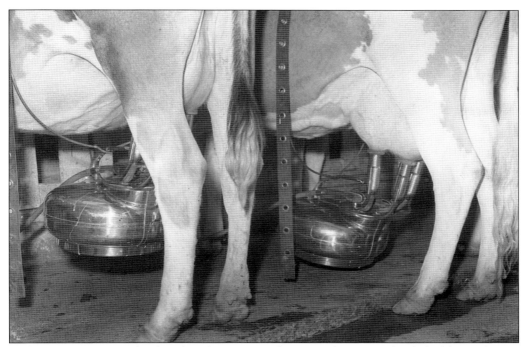

In the 1890s, inventors developed working suction devices and teat cups that led to the perfection of an automatic milking machine. After the 1920s, milking machines were an accepted part of the dairy industry. This milking machine from the 1940s demonstrated the ease and cleanliness with which cows could be milked.

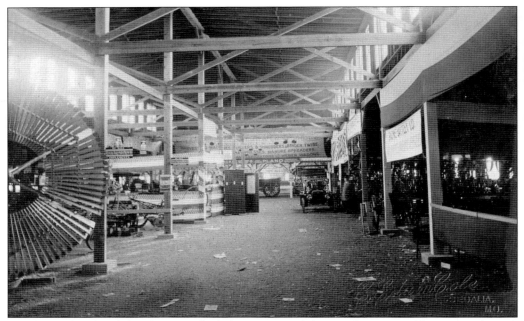

Charles Cole of Sedalia photographed the interior of the Machinery Building around 1905. Farmers visiting the Machinery Building could see the latest in harvesting machines, threshers, shredders, manure spreaders, hay presses, cream separators, and Weber wagons. The Rock Island Plow Company exhibited implements, as did the Plano Implement Company. The large object in the left foreground is a wood vane windmill. (Courtesy of Charles Wise.)

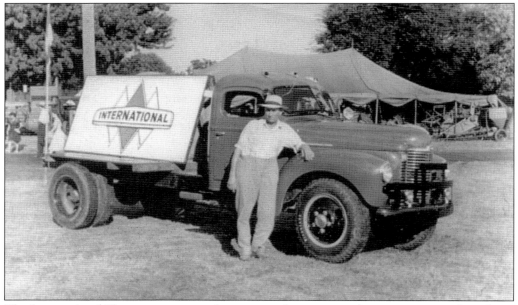

The International Harvester company began manufacturing combines, tractors, and trucks in 1907. This photograph shows an International truck and a rather tired fairgoer in the late 1950s. In the background is one of the many tents exhibitors used to provide protection from the weather for themselves, fair visitors, and their products.

Allis-Chalmers Company of West Allis, Wisconsin, a suburb of Milwaukee, began manufacturing farm machinery in 1914. The company, known for the bright orange paint used on its tractors, sometimes called Allis Orange, showed seeders, tractors, and field cultivators and advertised parts and service for its implements in the 1950s. In 1955, Allis-Chalmers purchased the Gleaner Combine Company of Independence, Missouri. Below are the fair secretary Wilbert Askew and others admiring a D15 tractor, introduced in 1960. The Future Farmers of America farm machinery exhibit is in the background.

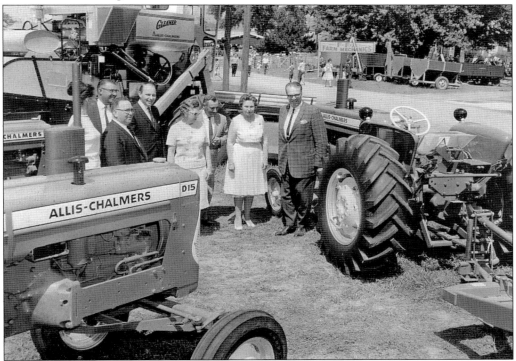

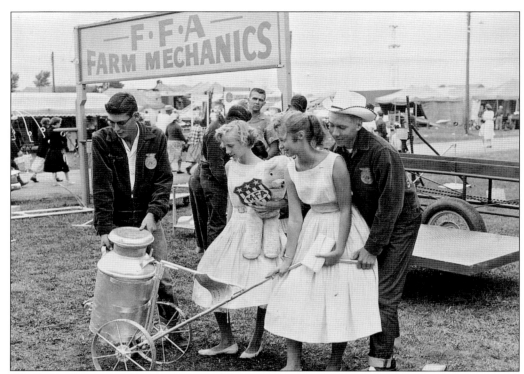

The Future Farmers of America organized in 1928 in Kansas City, Missouri. It encourages vocational agriculture students to become good leaders and to promote American agriculture. FFA members display livestock and crops as well as trailers and other machinery they have produced. These two FFA members demonstrate a milk can cart to two young ladies.

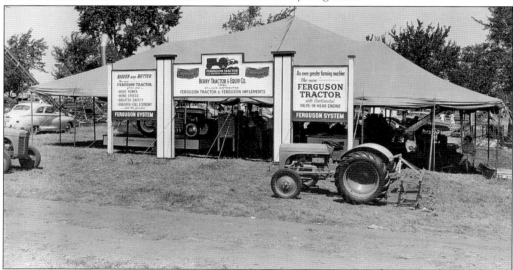

The Ferguson Tractor Company developed a three-point hitch that was used by the Ford Motor Company on its tractors prior to the end of World War II. Ferguson manufactured a range of farm machinery, some of which is shown here in the late 1940s or early 1950s, before the company merged in 1953 with the Massey-Harris Company to become the Massey-Ferguson Company.

Eight
AROUND THE TRACK

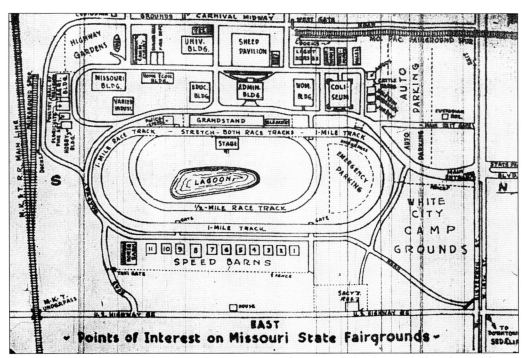

The one-mile racetrack, shown in this 1937 map, dominated the fairgrounds. The track was completed in 1901 in time for horse races at the first Missouri State Fair. In 1936, Works Progress Administration workers built a half-mile racetrack inside the earlier, longer track. WPA workers also built a decorative pool in the center of the racetrack, an additional barn for racehorses, a judges' stand, dressing rooms for performers, and a permanent stage. (Courtesy of *Sedalia Democrat*.)

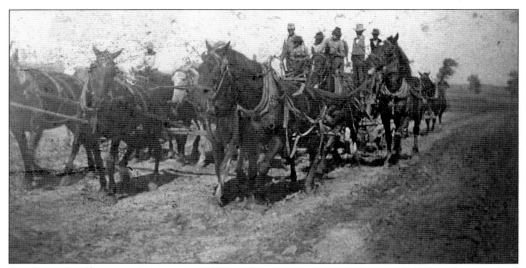

Work on the fairgrounds began in 1900 with construction of a racetrack. The planners had chosen a site on sloping ground for the racetrack, and contractors James A. Heck and George Menefee had to level the site by hauling fill dirt to the north side of the track and leveling the south side of the track. Using a western wagon loader and elevating grader pulled by 16 horses and guided by a gang of 10 teamsters, work on the track continued throughout 1900 and 1901. Progress was complicated by an extremely wet, cold spring and a hot, dry summer. George Kessler, who designed the fairgrounds, ordered Heck and Menefee to work overtime and purchase more equipment, including the dump wagon made by the F.C. Austin Company, so they could finish by September 1901, when the fair was set to open. (Above, courtesy of A.J. Heck; below, courtesy of Caroline Thomas.)

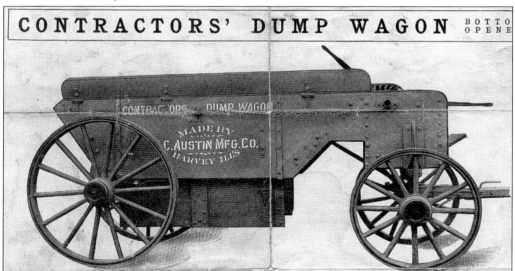

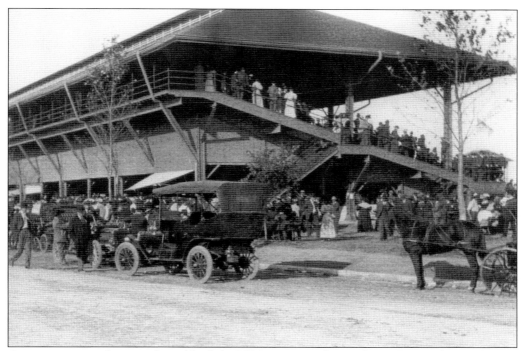

A temporary wooden grandstand built by H.M. Hammond served race fans at the fist fair. By 1902, however, the fair had built a structural steel grandstand facing the racetrack just north of the original Administration Building.

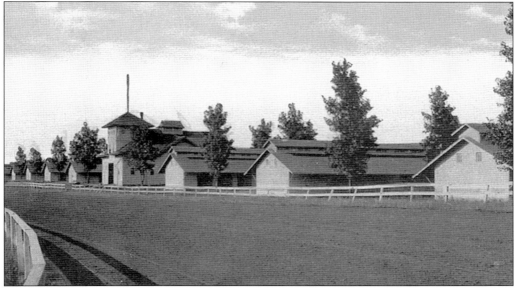

Horse racing was a major part of early fairs, and this stable for racehorses located near the eastern entrance to the fairgrounds was the first building erected on the fairgrounds. Thomas Bast designed the building, and H.M. Hammond completed construction in 1900. The building had sleeping quarters in the attic for attendants. In 1901, Thomas Johnson built 10 additional frame barns costing $554 near the large barn. (Courtesy of Sedalia Public Library.)

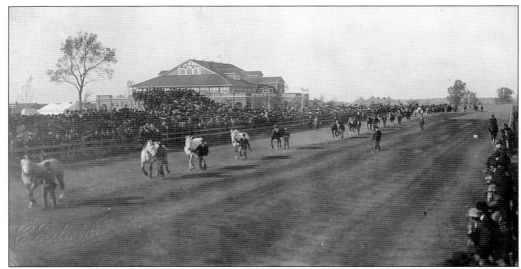

Charles Edwin Coles of Sedalia photographed these horses parading along the racetrack. A secondary area of seating north of the grandstand is full of spectators; more spectators line both sides of the track. (Courtesy of Charles Wise.)

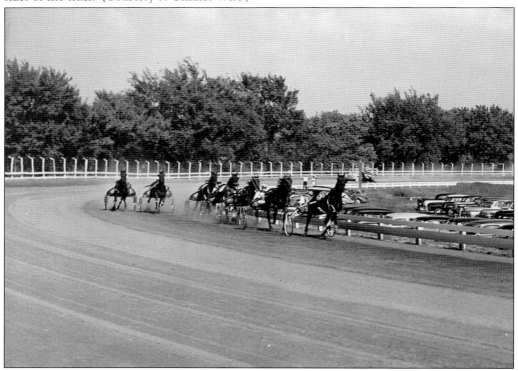

Harness races feature Standardbred horses pulling light carts called sulkies and moving at either a trot or a pace. A trotter moves its right front and left hind legs so they strike the ground at the same time, then its left front and right hind legs strike the ground at the same time. A pacer moves its right front and hind legs together, then its left front and hind legs. Horses crowd the turn in this 1949 race. (Courtesy of Missouri State Archives.)

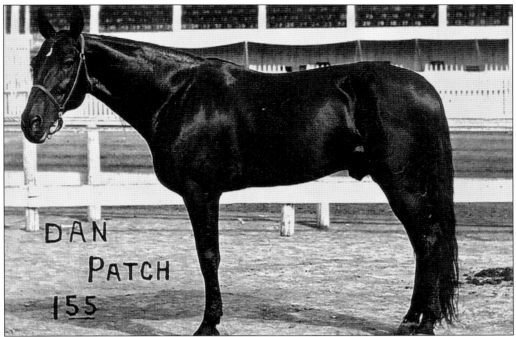

Dan Patch, said to be the fastest horse in the world with a record time of 1 minute 55 seconds for a mile race, raced at the Missouri State Fair in 1909 against Minor Heir, whose record time was 1 minute 59 seconds. Trainer Harry Hersey drove Dan Patch, and trainer Bill Turner drove Minor Heir. The race was close, with only one-quarter second separating the times of the two horses. Dan Patch won with a time of 2 minutes 7 seconds; Minor Heir's time was 2 minutes 7.25 seconds. The *Sedalia Democrat* estimated that 30,000 people witnessed the race.

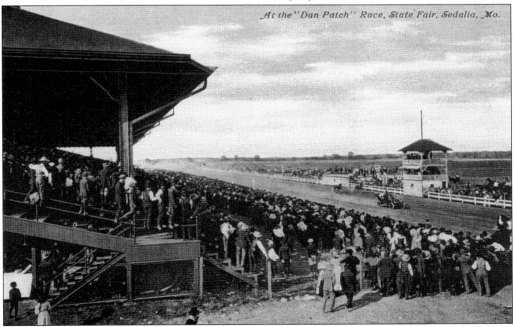

The elevated judges' stand gave judges an unobstructed view of the racetrack. This 1916 photograph from *Souvenir: Missouri State Fair, 1917* shows the judges stand overlooking the track where several men are seen standing while a horse prances past. The fence around the racetrack advertises a free concert and a horse show.

The Works Progress Administration built a new judges' stand in 1936s. This mid-century photograph shows the grandstand in the background and the new judges' stand on the left.

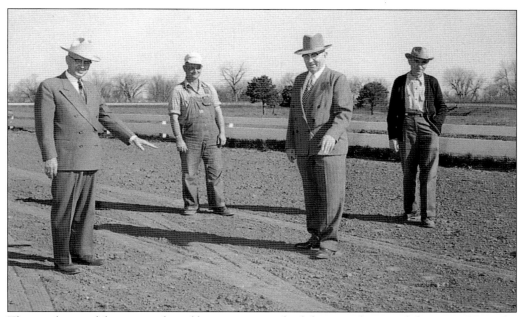

The condition of the racetrack itself is important in both horse and automobile racing. Here, the state fair secretary in 1954 and 1955, Ross Ewing (left), inspects the track with an unidentified administrator and two unidentified maintenance workers.

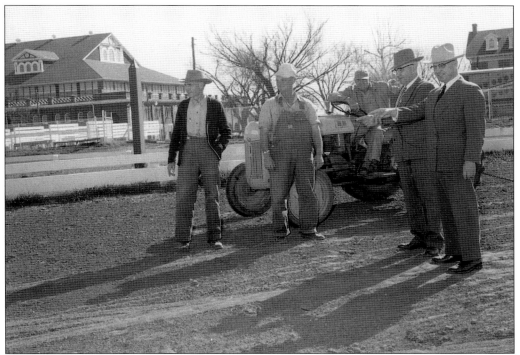

Daily maintenance of the racetrack requires a variety of machinery, from water wagons that spray the track to control dust to tractors with blades that smooth the track. Here, maintenance workers with a tractor prepare the track for a race.

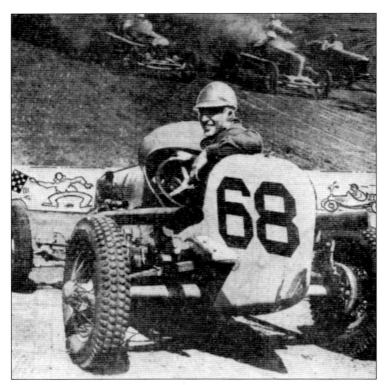

Automobile races were advertised in the *Sedalia Democrat* with photographs and flowery language designed to emphasize the danger of racing. This advertisement for the State Fair Classic shows Herb Manges in the foreground with a background scene of a race "as the pilots battle wheel-to-wheel and hub-to-hub for the flag through one of the treacherous turns."

This advertisement from the 1936 Missouri State Fair Premium book shows Gallopin' Gus Schrader, a popular driver of the 1930s. Schrader appeared at the Missouri State Fair in 1930 and again from 1933 through 1941. Called the "outlaw king of the dirt tracks," he dominated what was called big car racing. (Courtesy of Missouri State Fair.)

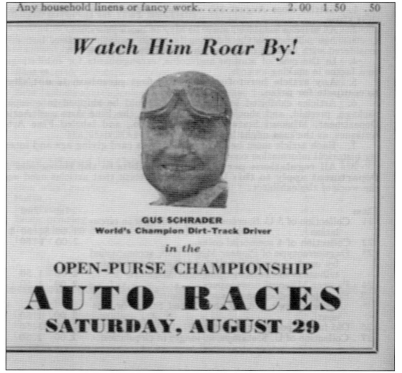

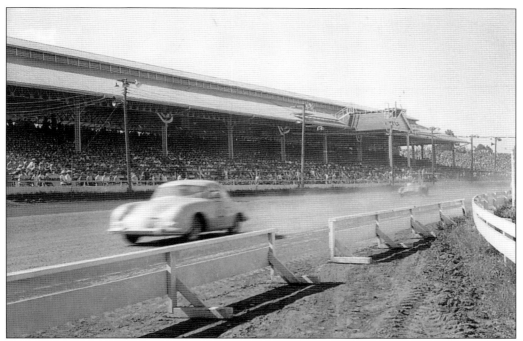

Stock car races began with the idea of racing the cars people normally drove on the street. Modified cars harkened back to the souped-up engines in cars used by bootleggers to haul illegal whiskey. In the 1950s, jalopies, what the Missouri State Fair referred to as this modified stock car, raced on the half-mile track. This grandstand is full at this 1954 race.

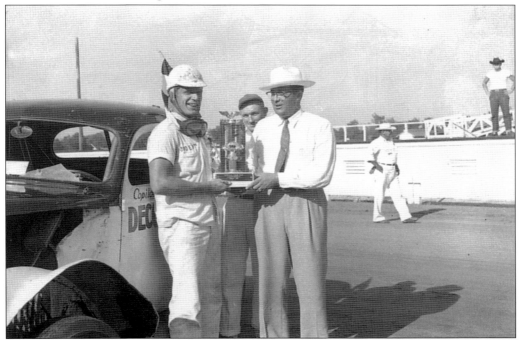

A fair official presents a trophy to a stock car race winner.

What had been called big cars in the 1930s was referred to as sprint cars in the 1950s when this race took place. The presence of people on the track suggests this photograph may not have been taken during a race.

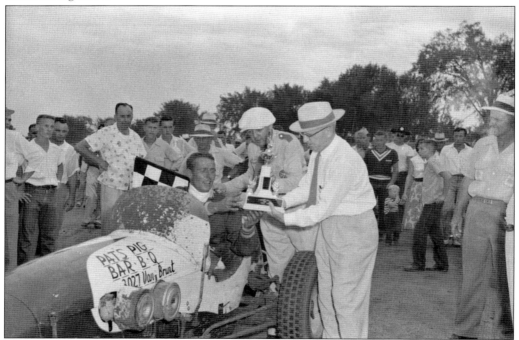

Bob Slater drove a car sponsored by Pat's Pig Bar B Q in Kansas City to a victory in 1954. Missouri State fair secretary Ross Ewing presents a trophy as Al Sweeny, race promoter, looks on.

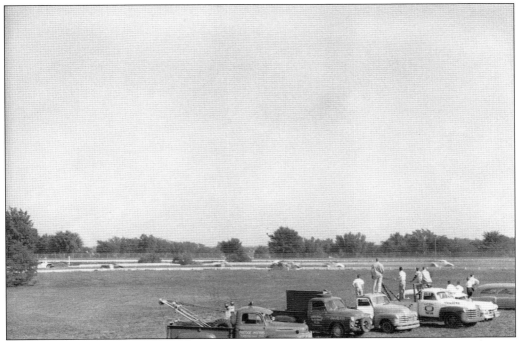

Fans on the grandstand look toward the start of the race.

Racing is a dangerous sport, with a constant threat of accidents that may harm cars, drivers, or spectators. Tow trucks, two ambulances, and emergency workers line the infield during this 1954 race.

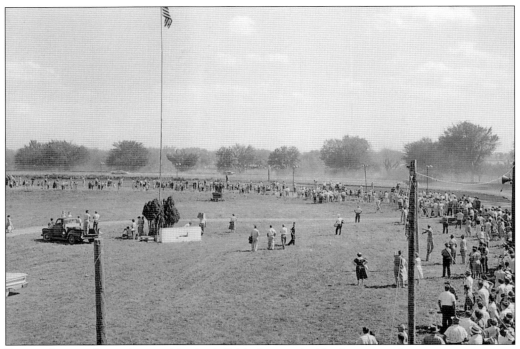

Fans with special permits stand in the infield, the area inside the racetrack.

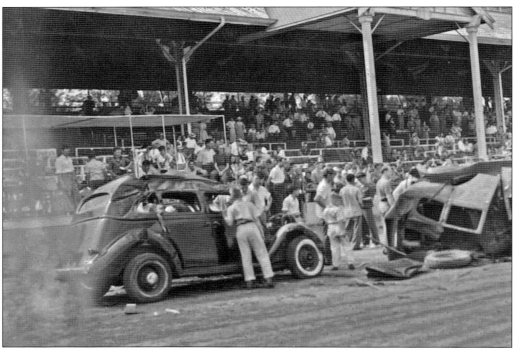

What appears to be an accident is actually part of an auto daredevils show that took place at the fair in 1955. Thrill teams competed to see whose drivers could perform the most daring stunts.

Nine
Fun and Corn Dogs

Organizers of the early fairs worried about the availability of food on the fairgrounds. Some church women's groups served meals at their facilities downtown, and a few enterprising people served light refreshments, such as homemade pie and lemonade, on the grounds at concession stands shown in this photograph. The *Sedalia Democrat* suggested that someone provide sandwiches and other more hearty fare for visitors. Many families brought picnic lunches and enjoyed eating on the grounds. Over the years, the number and variety of concessionaires increased, and fairgoers could choose from hamburgers, corn dogs, cotton candy, fried chicken, pork chops, or rib eye steaks. (Courtesy of *Sedalia Democrat*.)

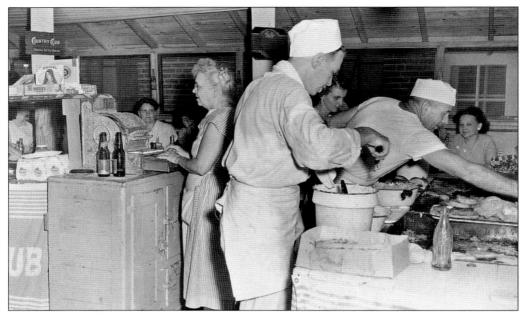

During the 1930s, the WPA built several permanent concessions stands to augment the stands already on the grounds. These stands were frame buildings with wooden awnings that opened during the fair to allow ventilation and were closed for security in the off-season. The cooks are busily preparing hamburgers while a cashier takes care of the cash register. Hungry folks occupy the stools. (Both, courtesy of Missouri State Archives.)

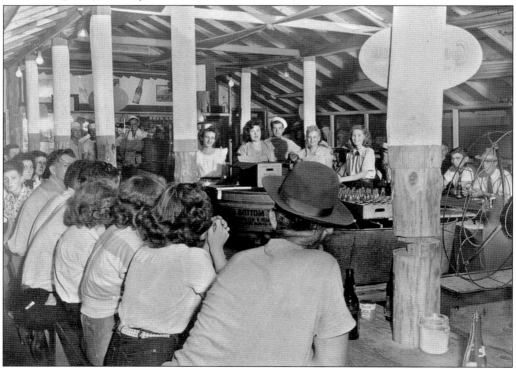

Skeet shooting contests, a test of marksmanship that involves shooting clay disks that are flung into the air, attempts to simulate the action of bird hunting as the shooter tries to hit a small moving target with a shotgun. In 1946, the Missouri State Fair held skeet shooting competitions.

Horseshoes, once a backyard pastime, was a formal competition at the Missouri State Fair in 1947 and remains so today. The Missouri Horseshoe Pitchers Association sponsors competitions at the fair at a permanent field on the west side of the fairgrounds. Here, a judge watches a competitor's form.

Fly-fishing contests and instruction were given in a pool built west of the Missouri Conservation Department Building in 1959. These women have won trophies and ribbons for their ability to land a fly in a specific spot.

Fairgoers preferring quieter competitions could take part in a checkers tournament advertised in the 1936 premium book. First prize was a silver loving cup. Competitors had to bring their own checker boards and checkers. (Courtesy of Missouri State Fair.)

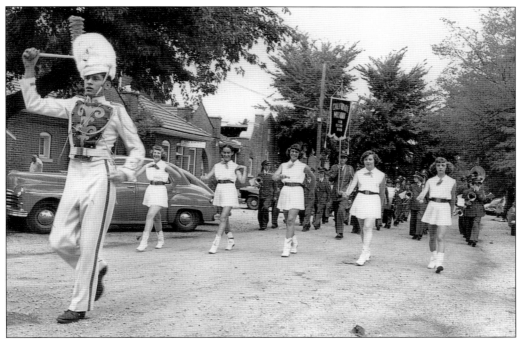

The New Bloomfield Band from Calloway County provided rousing music at the first fair; in the 1940s through the 1960s, school and community bands continued the tradition of parades through the fairgrounds each day of the fair. A drum major leads the California High School band from California, Moniteau County, Missouri. (Courtesy of Missouri State Archives.)

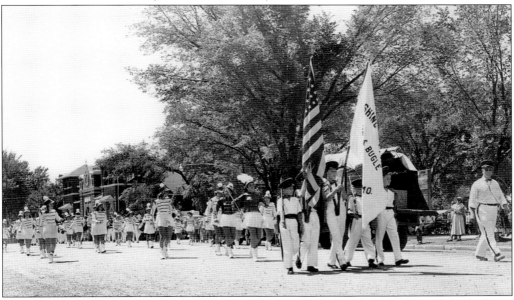

A color guard bearing the US flag and a large group of twirlers lead the Drum and Bugle Corps from Pershing, Gasconade County, Missouri. The patriotic theme of the unit may reflect pride in the town of Pershing, which was named for Gen. John J. Pershing, who lead Allied forces in World War I. (Courtesy of Missouri State Archives.)

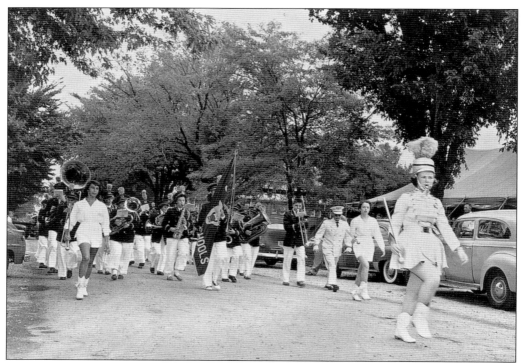

The Slater High School band from Slater, Saline County, Missouri, marches past cars, buildings, and tents in this photograph taken in the early 1950s.

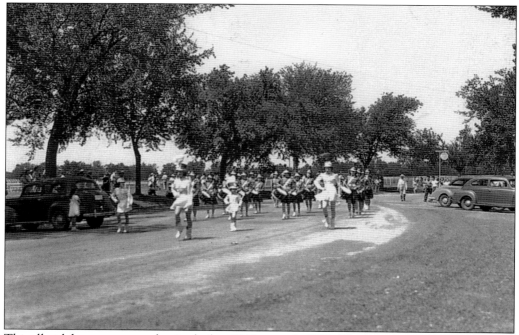

This all-girl drum corps marches in the late 1940s or early 1950s. The leaders appear to be carrying rifles rather than batons.

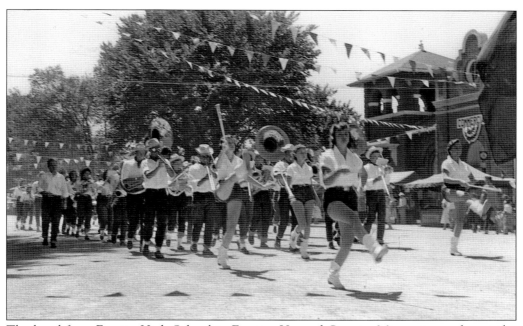

The band from Fayette High School in Fayette, Howard County, Missouri, marches at the fairgrounds in the late 1950s or early 1960s. (Courtesy of Missouri State Archives.)

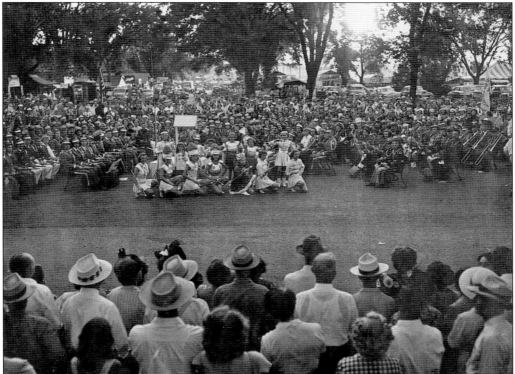

Group band concerts were popular entertainment in the evenings. Bands practiced the same music and then gathered at the fair to play together.

Music of a different kind accompanied exotic dancer Sally Rand, shown here clothed, with Sedalia politicians, including Herb Studer Jr., Abe Silverman, Aaron Haller, and *Sedalia Democrat* editor Kelly Scrutton to her left. Rand was best known for the fan dance, in which she danced naked behind two large ostrich feather fans. Rand, a native of Elkton, Missouri, appeared from 1951 through 1957, dancing in a burlesque show, awarding trophies at livestock shows, and visiting with dignitaries. (Below, courtesy of Missouri State Archives.)

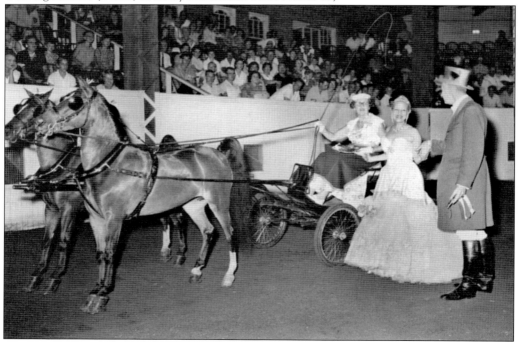

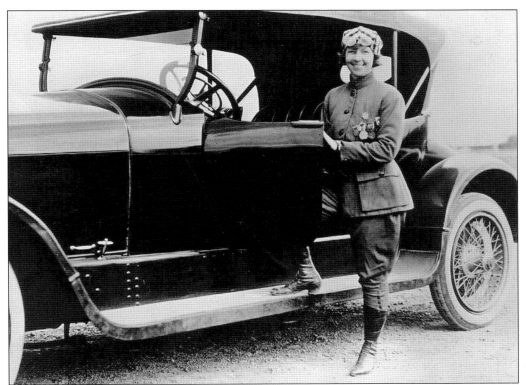

Air shows, especially those featuring daredevil pilots, were especially popular at early fairs. Women pilots demonstrated their competence. Ruth Law, shown standing beside her 1918 Marmon 34 car, set a record in 1916 for flying cross-country nonstop for 590 miles in an open cockpit plane. Law appeared at the Missouri State Fair with Katherine Stinson, another daredevil pilot. (Courtesy of Missouri State Archives.)

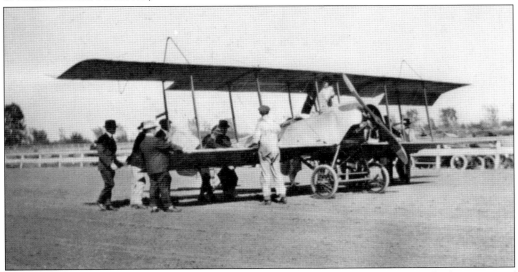

Airplanes were still a novelty in 1916 when this plane landed on the racetrack. (Courtesy of *Sedalia Democrat*.)

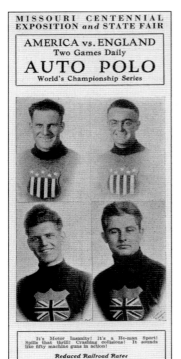

Advertised as "no place for sissy-boys or weaklings," Auto Polo was played at the fair in 1921 by teams from the United States and Great Britain. A driver steered a stripped down car carrying a mallet man who tried to hit the ball into the goal while the other driver, car, and mallet man tried to prevent him from doing so. (Courtesy of Missouri State Fair.)

In the 1940s, Jimmie Lynch's Death Dodgers, one of several thrill shows touring the carnival circuit, appeared at the fair. The show featured rollovers, deliberate crashes, and steeplechase racing over elevated ramps.

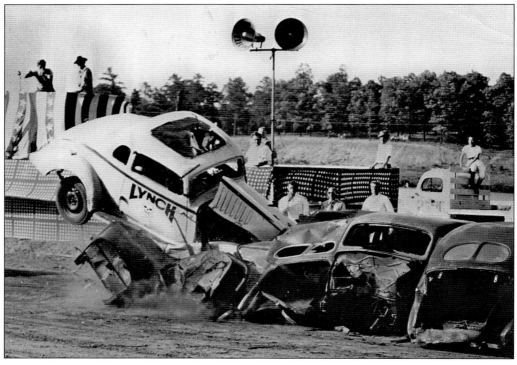

In the early 1950s, the fair sponsored a contest that gave away bicycles. The winners are shown here with the clowns.

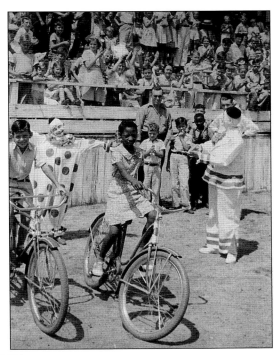

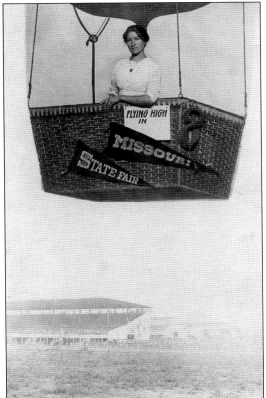

Trick photographs such as this one were popular souvenirs of the fair. The concessionaire had a backdrop with a fair scene and a foreground, here a hot-air balloon, behind which the fairgoer posed. The name of the event could be changed as the photographer traveled from show to show. (Courtesy of Charles Wise.)

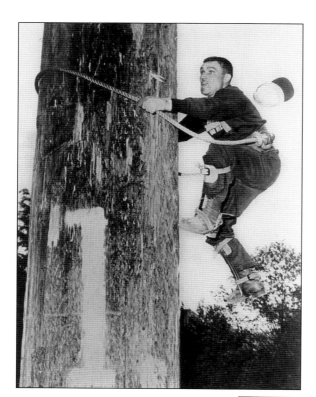

Danny Sailor, a world champion high climber, thrilled audiences as he climbed to the top of a 100-foot tall fir pole that was set up on the fairgrounds. He danced and did handsprings and headstands at the top. (Courtesy of Missouri State Archives.)

In 1942, the fair featured a World of Today Show with dancers representing many nations dressed in fancy versions of their countries native dress. Angelina Ramos from Hawaii was part of the show. The advertisement for her performance reflects wartime rhetoric with its pejorative references to the Japanese. (Courtesy of Missouri State Fair.)

FROM PEARL HARBOR

Angelina Ramos was born in Hawaii, a real South Sea Islander. Her parents still live there and, luckily, were unhurt when the cowardly Japs bombed the place last December. Angelina is one of the feature dancers in the Hawaiian Village, one of the feature shows of the World of Today Shows, the great Midway attraction at the greater 1942 Missouri State Fair. There are 10 fine attractive tented theatres and 16 thrilling rides on the streamlined midway of the World of Today Shows.

The "Idol of the Airlanes" Jan Garber performed at the 1942 Missouri State Fair with his orchestra. Garber's troupe included an orchestra and singers to provide music for dancing and comic skits between musical sets. (Courtesy of Missouri State Fair.)

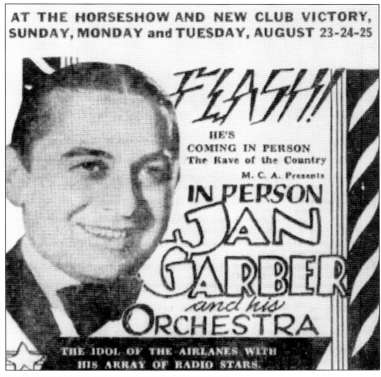

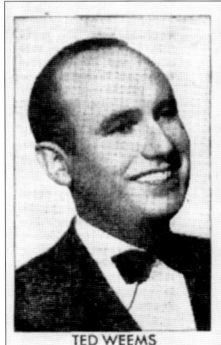

The Ted Weems Orchestra also played at the Missouri State Fair in 1942. Weems had a long career in radio that ended when he joined the Merchant Marines during World War II. Following the war, he formed another band and toured, playing nightclubs, state fairs, and other venues. (Courtesy of Missouri State Fair.)

115

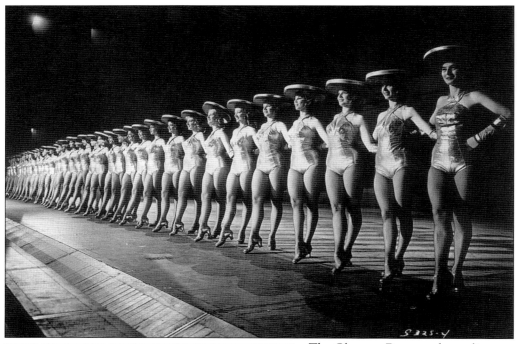

The Glamour Dancers chorus line was choreographed by Ralph Markert, who also choreographed the Radio City Music Hall Rockettes. (Courtesy of Missouri State Archives.)

Another form of comedy was provided by Robinson's elephants, a group of four pachyderms who stood on their front feet, balanced themselves on small stools, and danced on their hind feet. (Courtesy of Missouri State Archives.)

Ten

THE STATE FAIR CITY

Sedalia, which identified itself as the "Queen City of the Prairies," also billed itself as "The State Fair City." The location of the Missouri State Fair in Sedalia prompted a number of businesses to use the words *state fair* in their names. Some of these businesses were close to the fairgrounds; others were not. (Courtesy of Charles Wise.)

Dr. Julius Cannady, physician and expert in treating diseases of the skin, was an avid gardener. He created a correspondence course in gardening with monthly texts and lessons that sold to 10,000 students. Cannady owned the State Fair Floral Company, whose greenhouses were located just north of the fairgrounds. Cannady advertised his greenhouses as "the largest grower of cut flowers and pot plants and the only florist growing roses in Sedalia."

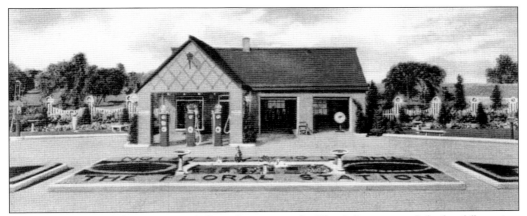

Cannady decorated the State Fair Filling Station, or the Floral Station, with beds of flowering plants, a decorative pond complete with goldfish, and a children's playhouse. A welcome sign greeted visitors in 30 languages. (Courtesy of Charles Wise.)

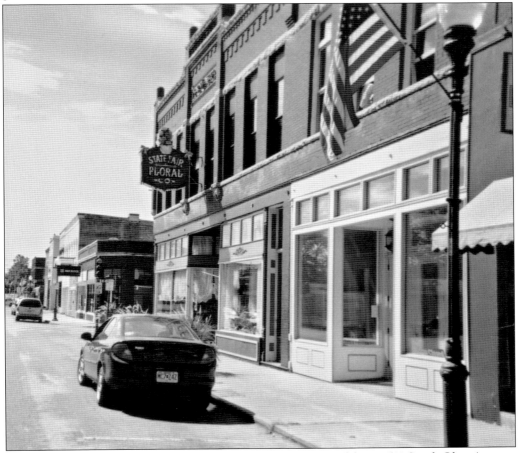

State Fair Floral Company maintained a store downtown. Located first at 512 South Ohio Avenue, the store moved to 316 South Ohio Avenue in 1915. The store is now located 520 South Ohio Avenue. The sign now used is from the earlier store.

The smokestack that served Cannady's greenhouses still stands as the cornerstone of the State Fair Shopping Center, built in 1966. Several businesses, including State Fair Laundry, State Fair Beauty Salon, State Fair Miniature Golf, and the State Fair Cinema, were located in the shopping center. (Courtesy of author.)

State Fair Restaurant, with a mural of a racing scene painted by Sedalia artist Pat Clark on its interior wall, was a popular eating establishment between 1966 and 1991. Many local civic organizations met in its banquet room. (Courtesy of Becky Carr Imhauser and Mike Hawk.)

At the time of the first fair, 16 cigar makers worked in Sedalia. State Fair Cigars, a "leading 5¢ cigar," was offered in a box decorated for Christmas.

Beiler's Grocery Company, one of Sedalia's many wholesale companies that dealt in foodstuffs, sold oatmeal under the brand name State Fair Rolled Oats; the box featured a picture of a large building that was not part of the Missouri State Fairgrounds. This box was found at Stony Ridge Lodge, John Bothwell's home north of Sedalia. It now sits in the kitchen of the preserved home. (Courtesy of Bothwell Lodge State Historic Site.)

In 1925, Miller H. Stroup opened the State Fair Grocery located on Sixteenth Street, two blocks east of the fairgrounds. A variety of men owned the store until 1950, when Leo Dick purchased the store. He managed it until 1966, when the popularity of large grocery stores in shopping centers began to mark the end of the neighborhood market. Now the Hair Haven salon occupies the building once used by the State Fair Grocery. (Courtesy of the author.)

In 1946, Walter Wertz opened State Fair Marine, selling boats and motors in a building on Highway 65 north and east of the fairgrounds. The store, whose address was 1419 South Limit Avenue, also sold beer and packaged liquor. The store later dropped its line of boats and dealt strictly with liquors, wines, and beers. The third generation of the Wertz family now manages the store. (Courtesy of the author.)

In 1913, Frank J. Holdner, who lived with his wife, Dolly, at 206.5 South Ohio Avenue, operated the State Fair Bar in this building at 113 East Second Street in downtown Sedalia. Although aluminum siding covers the transom and the building is dilapidated, it retains much of the appearance it had when the bar was open. (Courtesy of the author.)

Built in 1927, the Bothwell Hotel had a dining room and coffee shop but did not serve alcoholic beverages because the Vollstead Act was in force. With the repeal of Prohibition in late 1933, the hotel was free to serve alcoholic beverages. During the 1930s, Bothwell Hotel maintained a cocktail lounge called the Rendezvous; in 1946, the bar changed its name to the State Fair Cocktail Lounge.

In the 1960s, Sedalia's Holiday Inn opened. In 1977, it became the State Fair Motor Inn. (Courtesy of the author.)

A number of service stations have used the name state fair, including the State Fair Standard Service in the 1960s, State Fair Sinclair in the mid-1970s, and State Fair Amoco in the 1980s. State Fair Qwik Lube, opened in 1988 by Steve Emory and Jim Dugan, is the only one that remains. (Courtesy of the author.)

State Fair Community College opened in 1968 on a campus west of the fairgrounds in these prefabricated buildings. The college was lovingly called "Plywood U" by its students. The name State Fair Community College was chosen because of the college's proximity to the fairgrounds. (Courtesy of *Sedalia Democrat*.)

For many years, the college lacked a gymnasium, so the SFCC Roadrunners played basketball in the Agriculture Building on the fairgrounds. Here, SFCC player Colles Webb scores a two-point basket as players from East Central Community College defend the basket. SFCC players Lewis Busch and Charles Schell stand by to help. (Courtesy of State Fair Community College Archives.)

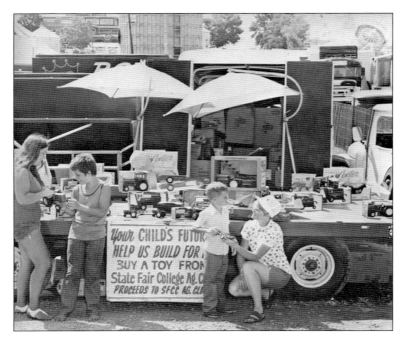

FFA students and the Agriculture Club have been associated with the fair almost since the SFCC's beginning. Here, Cathy Paxton and Connie Harrison of the Agriculture Club sell toy farm implements to future agriculture students. (Courtesy of State Fair Community College Archives.)

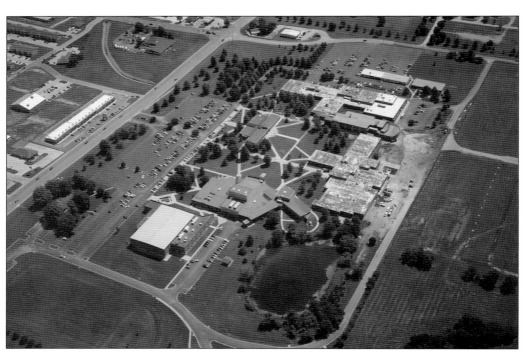

State Fair Community College now has six instructional buildings, the nationally renowned Daum Museum of Contemporary Art, a state-of-the-art theater, and a multipurpose building housing a gymnasium. Students are enrolled in its academic and vocational programs on the Sedalia campus, at satellite sites, and in online courses. (Courtesy of State Fair Community College Archives.)

BIBLIOGRAPHY

Chalfant, Rhonda. *Show Me the Fair: A History of the Missouri State Fair.* Virginia Beach, VA: Donning Company Publishers, 2002.

Christensen, Lawrence O., and Gary Kremer. *A History of Missouri: Volume IV, 1875 to 1919.* Columbia. MO: University of Missouri Press, 1997.

Claycomb, William B. *Pettis County, Missouri: A Pictorial History.* Virginia Beach, VA: Donning Company Publishers, 1998.

Conservation Commission of the State of Missouri. *The History of the Conservation Movement in Missouri.* 2nd ed. Jefferson City, MO: 1990.

Curran, Pat. "Norman J. Colman." *Dictionary of Missouri Biography.* Lawrence O. Christensen, ed., et al. Columbia, MO: University of Missouri, 1999.

Dains, Mary. "The Missouri State Fair: The Struggle to Begin." *Missouri Historical Review* 73 (1978): 23–53.

DeMuth, I. MacD. *A Feast of Cold Facts.* Rev. ed. Sedalia, MO: Fisher Printing, 1899.

Imhauser, Rebecca Carr. *Sedalia.* Charleston, SC: Arcadia, 2007.

Kirkendahl, Richard S. *A History of Missouri: Volume V, 1919 to 1953.* Columbia, MO: University of Missouri Press, 1986.

Commemorative Sesquicentennial Book Committee (Marshall, Missouri). *Marshall, Missouri Sesquicentennial, 1839–1989.* Marshall, MO: Green Printers, 1989.

Maserang, Roger. The Missouri State Fairgrounds Historic District. Nomination to the National Register of Historic Places.

Rodemyre, Edgar. *A History of Centralia, Missouri.* 1936. Rept. Centralia Historical Society, n.d.

Sedalia, Missouri: One Hundred Years in Pictures. Sedalia: Sedalia Area Chamber of Commerce, 1960.

"Sedalia, Missouri: The Commercial, Industrial and Educational Metropolis of Central Missouri. Sedalia." *Sedalia Evening Sentinel,* 1904.

Sisemore, Rhonda Chalfant. *An Illustrated History of Sedalia and Pettis County.* Doug Kneibert, ed. Sedalia, MO: *Sedalia Democrat,* 1990.

Smith, J.D., ed. *Souvenir, Missouri State Fair 1917.* Sedalia, MO: Sedalia Printing Co., 1917.

Wentworth, Edward. *A Biographical Catalog of the Portrait Gallery of the Saddle and Sirloin Club.* Chicago, IL: Union Stock Yards, 1920.

Williams, Walter. *The State of Missouri: An Autobiography.* Columbia, MO: E.W. Stephens Press, 1904.

Discover Thousands of Local History Books Featuring Millions of Vintage Images

Arcadia Publishing, the leading local history publisher in the United States, is committed to making history accessible and meaningful through publishing books that celebrate and preserve the heritage of America's people and places.

Find more books like this at
www.arcadiapublishing.com

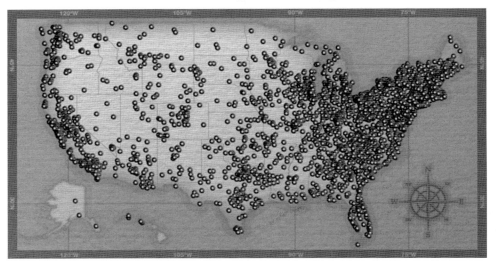

Search for your hometown history, your old stomping grounds, and even your favorite sports team.

Consistent with our mission to preserve history on a local level, this book was printed in South Carolina on American-made paper and manufactured entirely in the United States. Products carrying the accredited Forest Stewardship Council (FSC) label are printed on 100 percent FSC-certified paper.